Modern Artists

Christo

Harry N. Abrams, Inc., Publishers, New York

Lawrence Alloway

Christo

Jacket illustrations
Front: Package (detail). 1961
Back: Packed Hay (detail). 1968

Standard Book Number: 8109–4402–2
Library of Congress Catalogue Card Number: 72–82873

A connection has been proposed between Christo and Dada by William Rubin, who noted that Man Ray "was the first to wrap an object. But his gesture remained unique".[1] "His *Enigma of Isidore Ducasse* was a mysterious object—actually the sewing machine of Ducasse-Lautréamont's famous image—wrapped in sackcloth and tied with a cord. It anticipated the recent *empaquetages* of Christo, who has even greater aspirations, such as packaging certain skyscrapers of Lower Manhattan"[2] (plate 49). The differences seem greater than any connections with Christo, however. Man Ray's object was, as Rubin observed, "mysterious", at least until the contents of the package were recognized; then it became suggestive. Its content is the sexuality of Lautréamont's image of the umbrella encountering a sewing machine on a dissecting table. Thus, the covered object of 1920 was well within the boundaries of the erotic iconography which is what so much Surrealism (and some Dadaism) amounts to, only. This has little in common with Christo's use of the package in which the identity of the contained object is not subject to games of transformation, but remains itself. We can indicate the function of literalness in Christo's work if we consider the course of his development.

In Paris in 1958 he made his first series of objects, called *Inventory*, in which he mixed wrapped, painted, and unmodified articles (plate 1). This variety of treatment, however, was soon reduced, either by the use of repeated identical objects or by the total wrapping of objects. In 1959 he made tables which carried wrapped objects, packaged in such a way as to obscure their identity (plates 5–7). Here Christo began an exploration of the geometry of surfaces; as the covering stretched from point to point of the enclosed object or objects, the connections made new forms as they spanned the area. There was an ironic play between the new surfaces and the concealed supports; the packaging obscured, wholly or in part, the core, but without destroying the impression of containment. Two exhibitions at the Galleria Apollinaire, Milan, demonstrated the range of this work by 1963. The first show consisted of numerous packages, containing objects made bizarre by the wrapping: each known object was close at hand and, at the same time, removed. Transparent plastic was stretched or crumpled in improvised membranes. There were references to the ubiquity of modern packaging and to striptease, in which delays and refusals to unwrap are central.

The catalogue for this exhibition[3] reveals clearly one aspect of Christo's earlier work. It is a single sheet, of photographs and *textes trouvés*, dealing with packaging in terms of advertising. "We're deep in packaging"; "Packaging often ranks next to product in influence upon a buyer"; "Why not let our packaging people help you?"; and "Westvaco packaging gives you impact. What else? It protects. It innovates, trims costs". The found texts include one from the Container Corporation of America, naturally, though

Christo missed the automobile ads of a year or so earlier which explored the notion of cars as "packages for people". The catalogue stresses Christo's interest in the aesthetic potential of industrial processes or, conversely, the industrial content of an art using found and readymade objects. In Paris he was affiliated with the New Realists who, in different ways, were also concerned with the interlace of personally constructed art and the common materials of urban-industrial culture.

The second exhibition in Milan consisted of one huge package that almost filled the gallery, in its scale recalling a 1961 project of Christo's for a wall of oil drums built in the Rue Visconti, Paris, in 1962 (plate 30). The project is presented with high specificity. The street is measured, the shops are listed, an historical point of interest is quoted from a guide book, and the materials are specified: "Metal drums used for transporting gas and oil (with different labels, like ESSO, TOTAL, SHELL, BP) of fifty or two hundred litres capacity", and so on. Acceptance of the trade names is significant: they function as a block to symbolic interpretations of the kind present in Man Ray's allusive object. What Christo is doing is re-contextualizing known objects, not modifying them. He adds in his project that "This *iron curtain* can be used as a barricade during public work in the street, or can be used to transform the street into a Dead End. Finally, this principle can be extended to a quarter, even to a whole city". The Temporary Wall was put up in June 1962, as an extension of the programme of Pierre Restany's Galerie J into the streets.

Objects such as a chair (plate 25), a pram, or a bicycle (plate 10), built for use, when mantled or inverted, both invite and resist participation. The function of these objects is interrupted by Christo at the level of use, not of symbolism. He is not making the objects enigmatic or dreamlike; he is violating our operational relationship to the objects. They are distorted, but not hallucinated. It was Christo's intention to provoke reactions in the spectator, but these were to be physical and behavioral, rather than erotic, as in Dada and Surrealist objects. It is more like experimental psychology than psycho-analysis; there is action rather than reminiscence; the maze replaces the couch. When a known object cannot be operated in the customary ways, the reflexes of the spectator, in terms of expectation and reaction, are aroused, but suspended. Belief in a reflexive, participatory mode of art is central to Christo's work, both the earlier objects and the later environments.

Gradually Christo moved away from the object, a shift that came about empirically as a result of anxious work, and not as the result of planning. In 1963 he made a group of vitrines which, in retrospect are of the greatest importance (plates 33, 34). These showcases had paper on the glass to hide the interiors, but electric lights inside attracted attention to the denied function of display. **VI**

Christo's earlier objects had been characterized first by textural contrast and later by a substratum of organic reference in the membranes of polyethelene. With the vitrines, however, he avoided any associative elements: aluminium, glass, paper, electric light, were used straight, in a way that prefigures all his subsequent work.

In New York in 1964 Christo made his first store front; it is both an extension of the vitrines of the previous year and a fantastic expansion to full architectural scale. The idea of packaging now appears as the shielding of the internal space from the viewer. Christo constructed a store front, of a vernacular New York design, which confronts the spectator solidly (plates 36, 38). However, the points at which we expect to enter, either by looking in the window or by opening the door, are inoperative. It is as fully sealed as the bricked-up houses that coincided with the line of the Wall in Berlin. The early storefronts are touched by the romanticism of old New York, an effect emphasized by the tender and exact sense of human scale implicit in the architecture which Christo scrupulously preserves. The store fronts radiate a kind of suspense, as if the blocked windows or the closed door might admit one if you only knew the hours of opening. However, our perceptual and physical links are arrested as the invitation stays unfulfilled. What Christo has done is to turn physical space into psychological response, as the façade becomes a wall, absolutely cancelling the inside. In 1965–66 the development of the store fronts paralleled that of the packages and moved to a stricter, harder form. The later façades are more severe and less diverse in colour (plates 37–39). Christo evokes the mid-century production line rather than the nineteenth century craftsman as the source of form. It is worth remarking, as a sign of Christo's tact (which is a short word for unostentatious thoroughness), that the style-characteristics of both types of store front are inconspicuous. The older architectural forms have a minimum of specific ornamental details and the new store fronts have the anonymity of standard parts. As nearly as possible Christo's store fronts represent a zero style vernacular, with the minimum of elaboration compatible with total plausibility. (It is like Gloria Grahame's comment on the style of a hotel room in Fritz Lang's *The Big Heat:* "It's nice. Early Nothing".) Christo's simulated places are intimately known but topographically anonymous: he achieves what might be described as "schematic familiarity".

Constant in Christo's art for the last ten years is the use of objects at the same size as life, either by incorporating real objects in his art or by simulating real places. The packages of 1959–65 stretched plastic membranes over objects, so that the top skin, the outside of the package, determined the content of the work, and not the contents within. The identity of the internal, supporting

objects was withheld rather than obliterated, because Christo, like other artists of his generation, wanted to combine, in a double focus, an untransformed object with a new object, the work of art. The tendency of figurative art has been to synthesize signs for objects with properties internal to the work of art, to produce a sign-cluster readable both as referent and as formal structure. The work of art is in the middle, in a complex state of mediation. In Christo's packages, however, we are faced with an original object, a core he has not made, and a skin that he has. In the store fronts, real space is occupied, but in a similarly complex way. The original object is known, at least as a type or class, and exists as a level of reference, along with Christo's own scenic decisions. We are presented, therefore, with a double-layered rather than a unified image, consisting of two objects. It is a way to combine the literal (in terms of solidity and *thereness*) with the making of a new structure (the entertainment of the artist).

The form of Christo's solution to this shared interest, which might be formulated as the literalization of art, without relinquishing formal control, is logical and convincing. The early packages were domestic in scale, but soon expanded from table-tops (plates 5–7) to the hardware of transportation (plates 8, 10, 11), culminating in 1963 with the wrapping of a Volkswagen (plate 24). In the following year he began, with the store fronts, to play with the paradoxes of inside-outside space (plates 41–44). In the studio or gallery, space is suddenly reversed, as the spectator confronts the one-sided, faithfully-scaled stores; doors, windows, fascias, all human in scale, but not serving as an outlet for goods. The result is not a frustration of consumer expectation, but an experience of re-contextualization. As art becomes more literal, control passes from, say, the act of drawing to the act of contextualization.

The store fronts have subtle correspondences with the space of urbanism, as well as being one-to-one replicas of architecture's human scale. For instance, it is psychologically true that we experience most buildings that are sited directly on the sidewalk mainly in terms of the first storey; the second floor and above are virtually invisible. Hence the store front (or the foyer) is, in itself, the best known, the most public zone of a building; the threshold is the focus of attention. Thus, when Christo seals show windows with sheets or with paper, he cancels the internal space that we anticipate and defines space as what is between us and the glass. The spectator's investigattive, voyeuristic impulse is converted into an experience of himself, as an object in space. As of the packages, it is true to say that there is concealment but no illusion. The reponses generated by the screened object or the familiar façade are based on the objective act of making a package or screening a window. The factual basis of such art is neither transcended nor undermined: it is the source of the mystery. Christo is the antagonist of the imaginary.

Christo made other Temporary Monuments, in addition to the rue Visconti wall: in Cologne (plate 46) and in Gentilly. These works, improvized with urban waste (the only material available in sufficient numbers or sufficient bulk) were accompanied by projects for work on a bigger scale, without the materials of junk culture. In 1961 Christo drafted a *Project for a packed public building* (plate 47), to be "completely enclosed because packed on every side. The entrances will be underground, placed about fifteen or twenty metres from the building. The packaging will be of rubberized tarpaulin and reinforced plastic material reinforced at average intervals of ten to twenty metres, by steel cables and ropes. The packed building could be used as:

1. Stadium with swimming pools, football field, Olympic stadium or hockey and ice-skating rink,
2. Concert hall, conference hall, planetarium or experimental hall,
3. Historical museum, of recent or modern art,
4. Parliament or prison."

Here is a clue to another aspect of Christo's aesthetics, which has to do with the location of meaning, usually regarded as the central value of art, transmitted by the artist and received by the spectator. In architectural terms, however, Christo proposes to locate meaning in the subsequent usages of a building, and speculates on what these might be. Similarly in his objects and thresholds he is creating a situation in which meaning is in the variables of the spatial experience of the spectator and cannot be predicted accurately by the artist. Thus meaning follows the making of the work of art, instead of preceding it, or growing with it. Christo's category of Temporary Monuments is important, an acknowledgement, among others in the post-war period, that the value of art is not exclusively bound to ideas of fixity or permanence. He has accepted a temporary status for his art when he has packaged whole trees (plate 45), which will die and shrink, or girls (plates 14–21), whose tolerances of their mantles is limited. Other temporary situations were Christo's arrangements of oil drums, on the docks in Cologne (plate 31) and in the street (plate 32). The aesthetic of an expendable art is no less serious, no less rigorous, than that attached by idealist art criticism to supposedly immutable works. The huge scale at which Christo is now able to work presumes impermanence. The art is occasional, but our involvement with an occasion can be as satisfactory, as absorbing, as with art of an hypothetical permanence. In 1968 Christo packed the Kunsthalle, Bern, to celebrate the museum's fiftieth anniversary (plate 54); the nature of the building provided the occasion. At Spoleto, Christo wrapped two buildings, on the occasion of the city's festival (plates 52, 53).

At Kassel, for *documenta* 4, Christo demonstrated his capacity to work on a huge scale, not by covering an existing structure, but by creating an entirely new form. The *5600 cubic metres package* is a 280 feet high fabric envelope with a diameter of thirty-three feet (plates 59–70). It was designed by Christo in consultation with Mitko Zagoroff, an engineer at Massachusetts Institute of Technology. The first project was to support a transparent skin with internal chambers of helium, but the second version, which is the one that stayed up, is supported by air and guy ropes (12,000 feet of them), and is opaque. It was set in the Park at Kassel, between the Orangerie and the lake, huge—about the height of Mies van der Rohe's *Seagram Building*—but as nervously responsive to air pressures as a tendril of seaweed to water currents. The package is huge but visibly sensitive. The process of working at this scale involves the artist in problems of funding and logistics, from consultations beforehand, finding the material, making working drawings and models, to on-site improvization.

One advantage, or beauty, of the artistic process since the sixteenth century has been that it is a situation of total control; all decisions, conceptual or technical, originate with the artist. To work on the scale of the *5600 cubic metres package*, on the contrary, involved other people beside the artist, from the planning to its building. The artist is thus engaged socially, in a way dissimilar from the traditional studio situation. (Operationally, Chardin and Pollock, for example, are more like than unlike one another; on the whole, the avant-garde of the twentieth century has been highly conservative in work-sharing methods). Christo surmounted these problems brilliantly, and showed his capacity to make a second start on the site, after the loss of several thousand dollars worth of helium.

He has found a way of making current art operate on the scale of the city, without resorting to covert forms of Baroque monumentality, as in most new works intended for public sites. He proposes, as a reality, a new spatial scale for art which would at least match, in duration and area, a carnival or a play. His training in the middle '50s with Sergei Vasseliev (Meyerhold's follower) and F. F. Burian (Brecht's friend) developed the capacity to plan for big spaces, build models, and visualize graphically. Christo's monuments are important because they realize in terms of objects a scale which otherwise remains largely untouched in art, except in later Happenings. Other big schemes, such as Mack's Sahara Project, frequently depend for their grandeur on the fact that they are not working projects. Oldenburg's scale-twisting monuments are basically conceived in terms of the *capriccio*, for instance (paintings which juggled monuments in new topographies). The problem is to get art on the new scale out of the project X

stage into the realm of objects and events (without just littering up the world with bigger Henry Moore's and Alexander Calder's). Christo does this, without any softening of the line his art was following before he went public.

Christo said recently, "I want to present something that we never saw before. Something that is not an image, but a real thing— like the pyramids in Egypt or the Great Wall of China. The China Wall is the most completely old-fashioned product, but it is one of the most marvellous things. Two thousand years old. It is implacable".[4] As he has been able to move away from reliance on waste products, he considers his Temporary Monuments can now be less precipitiously temporary; their short – life characteristics can be, perhaps, extended, phased more slowly. "The new materials I use are more permanent. The Kassel package is very strong and can stay perhaps ten years. I would like to make a product too, and keep it up for a long time".[5]

Notes

[1] William S. Rubin, *Dada, Surrealism and their Heritage*. Exhibition catalogue, The Museum of Modern Art, New York, 1968

[2] William S. Rubin, *Christo Wraps the Museum*. Foreword in Exhibition catalogue, The Museum of Modern Art, New York, 1968

[3] *Christo*. Exhibition catalogue, Galleria Apollinaire, Milan, June-July 1963

[4] Conversation with the author, September 1968

[5] *Ibid*.

Illustrations

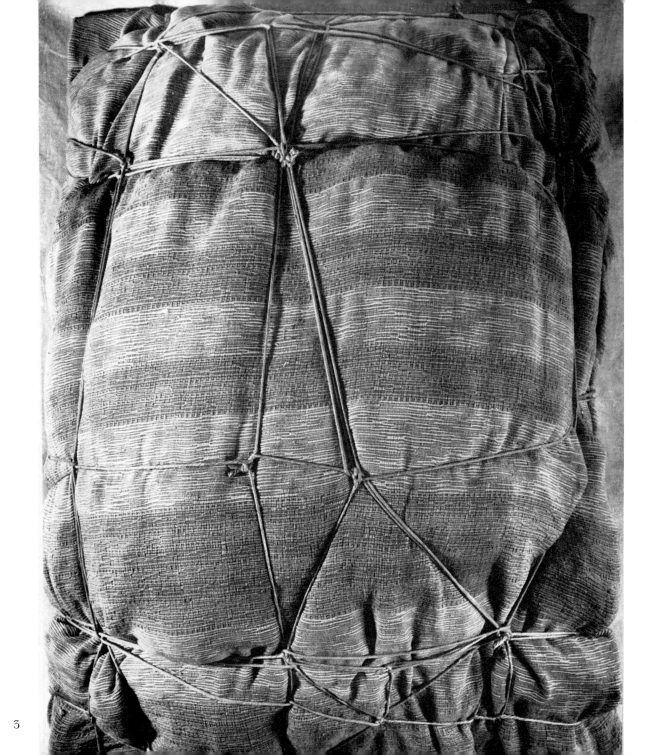

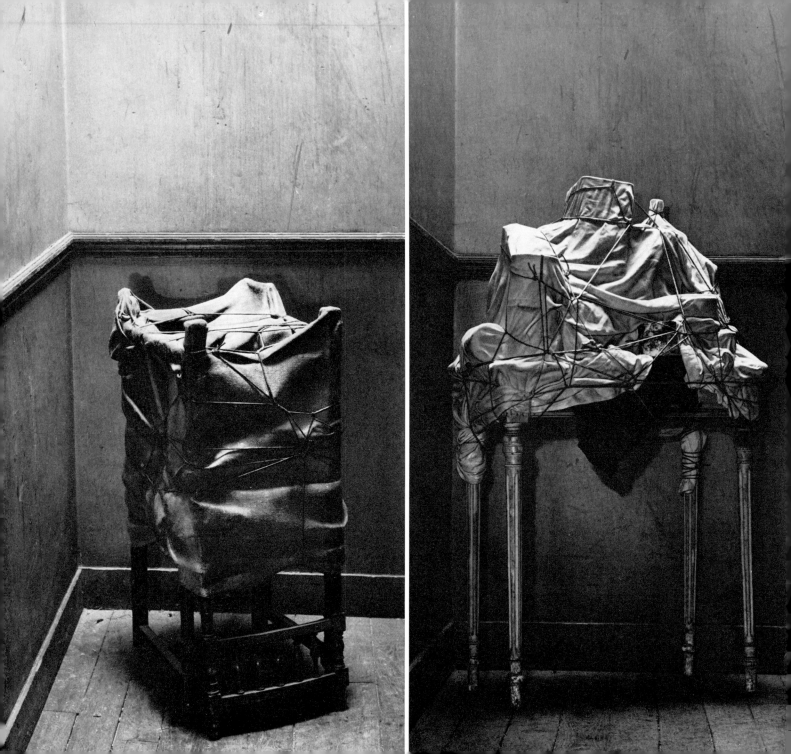

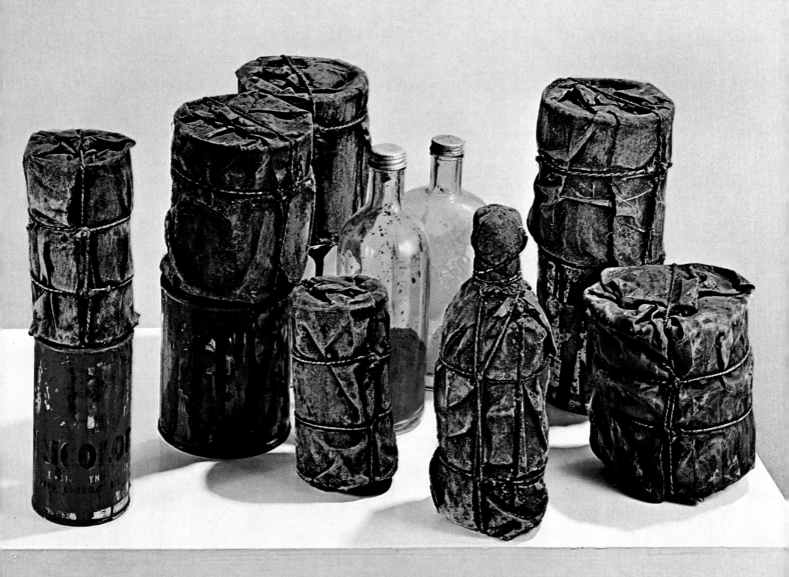

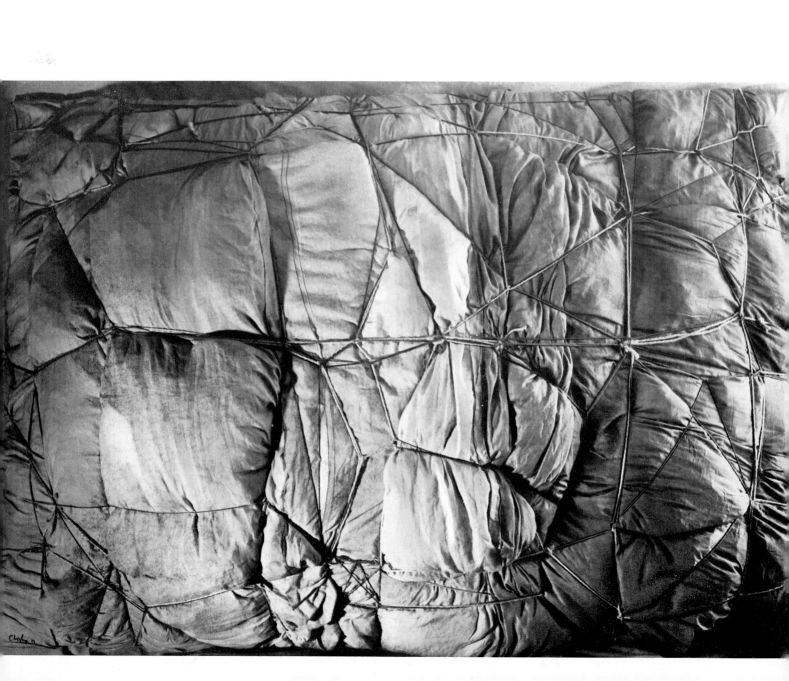

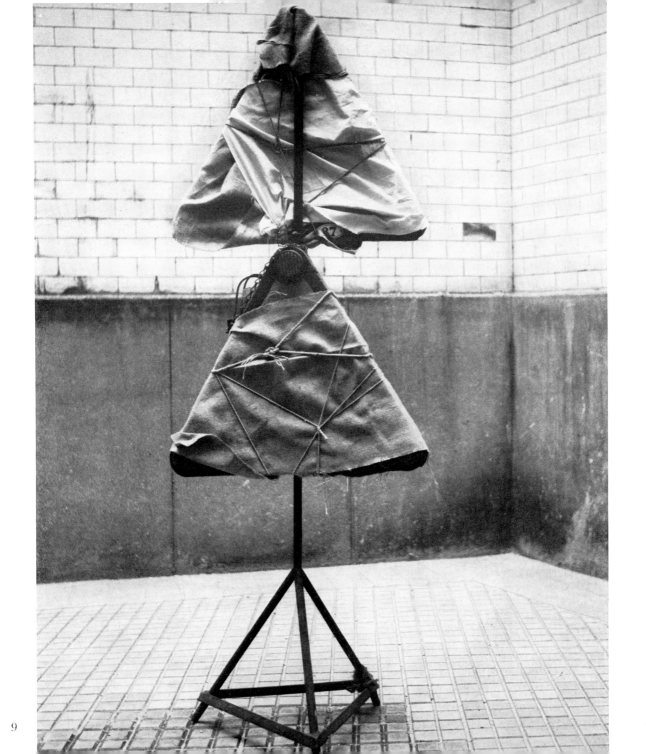

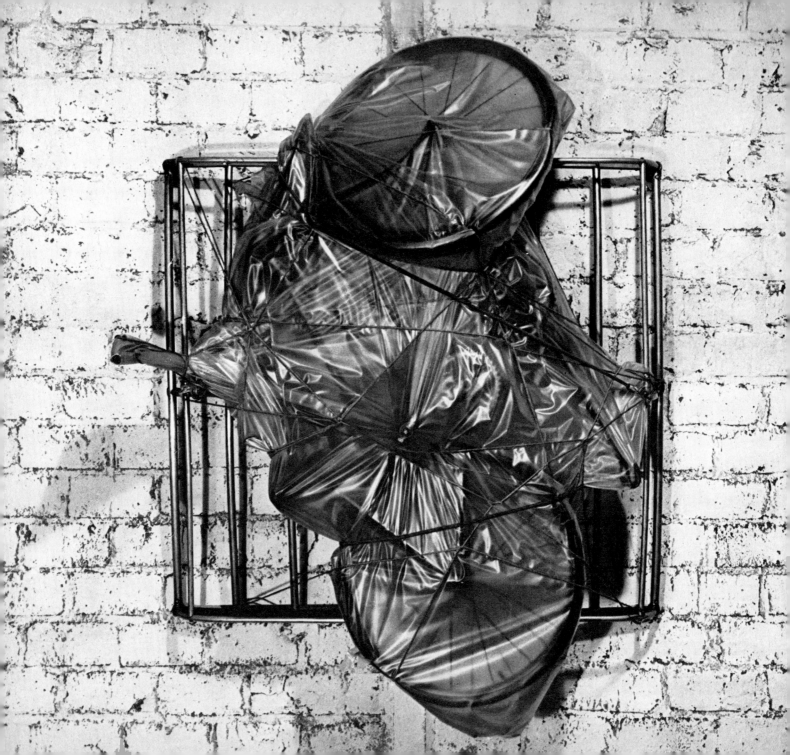

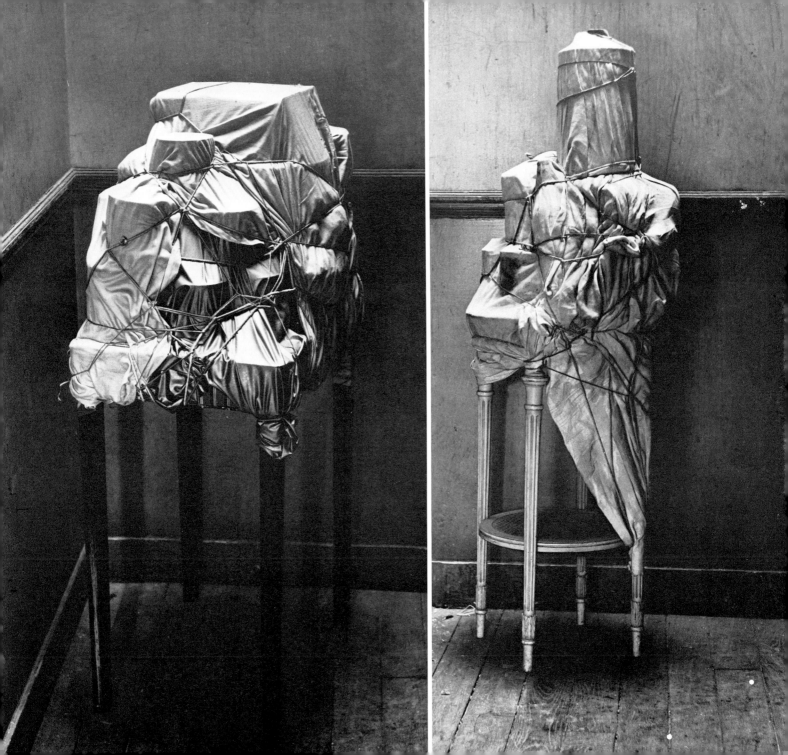

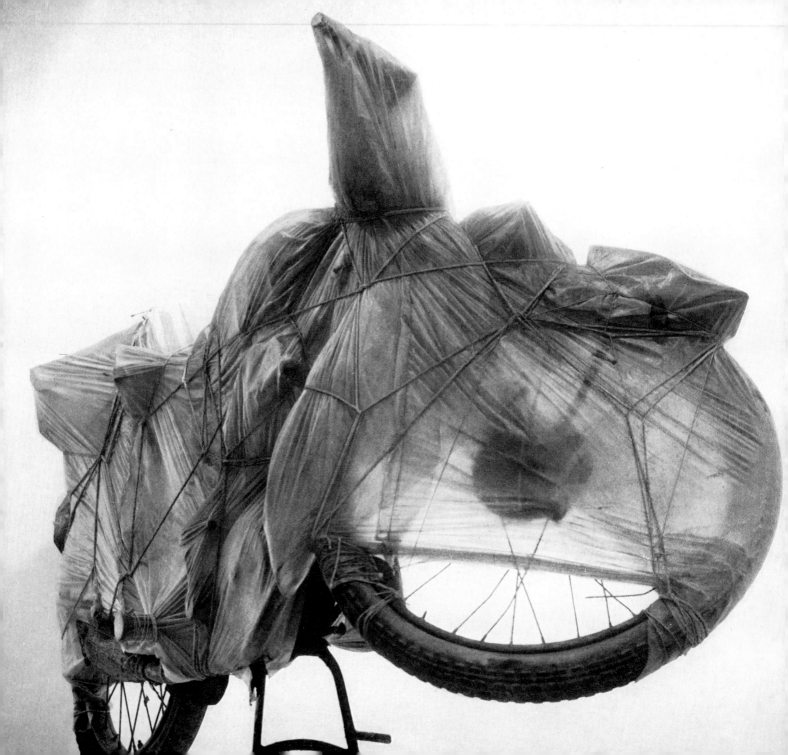

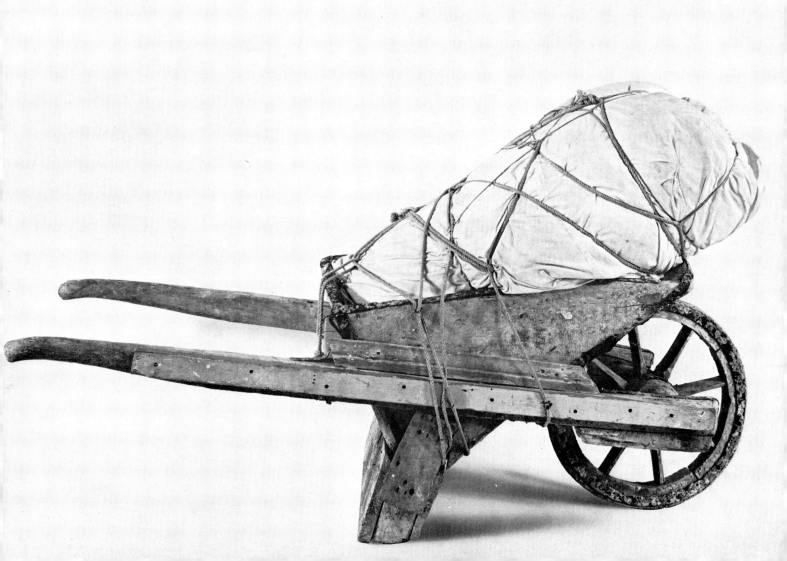

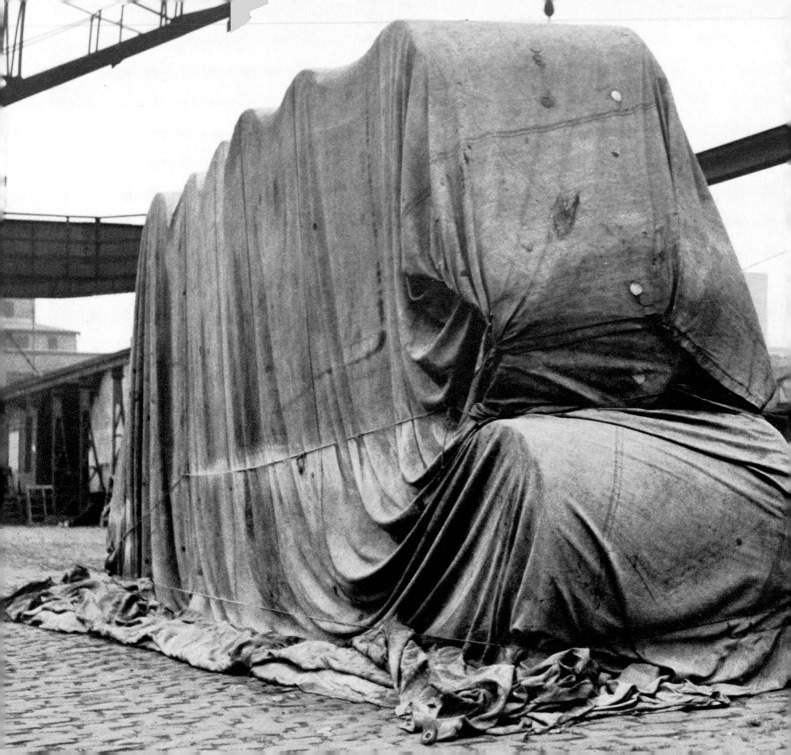

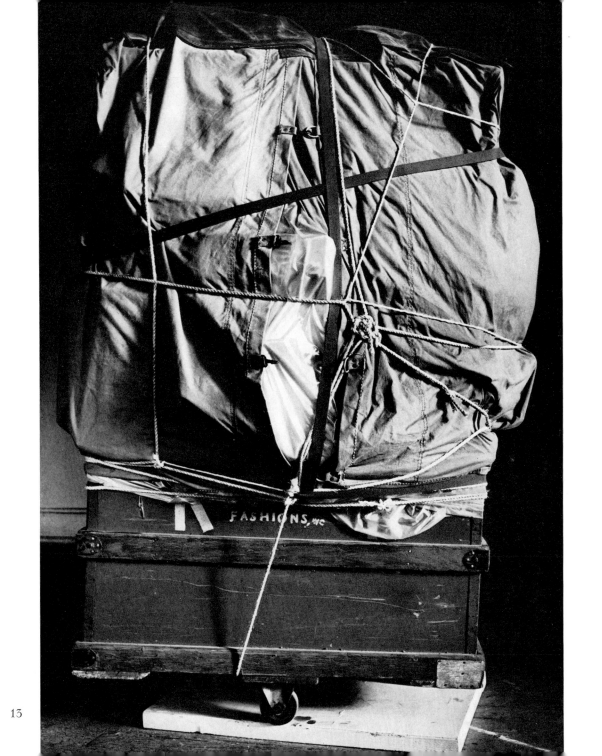

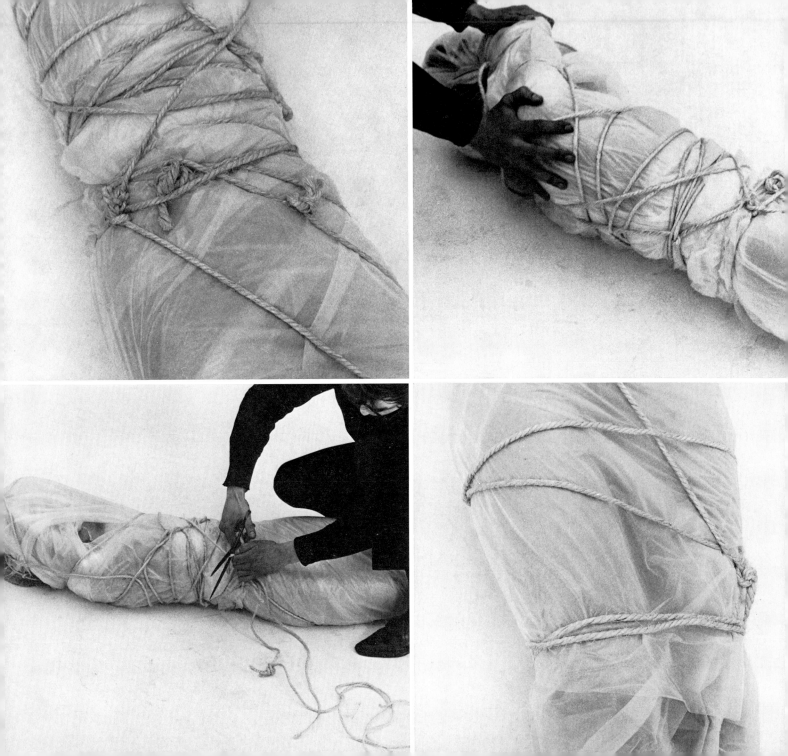

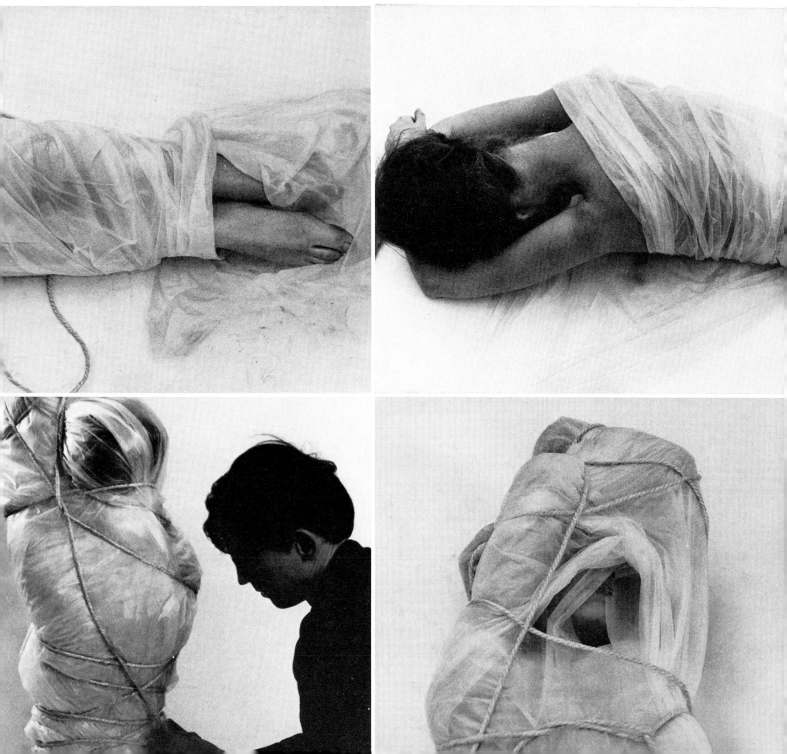

Arbre emmaillotté (projet: ciseau en acier: 48 ; longueur 140° ~ 10 F empaqueté : bon toile de sac et plastique) Christo 64-65

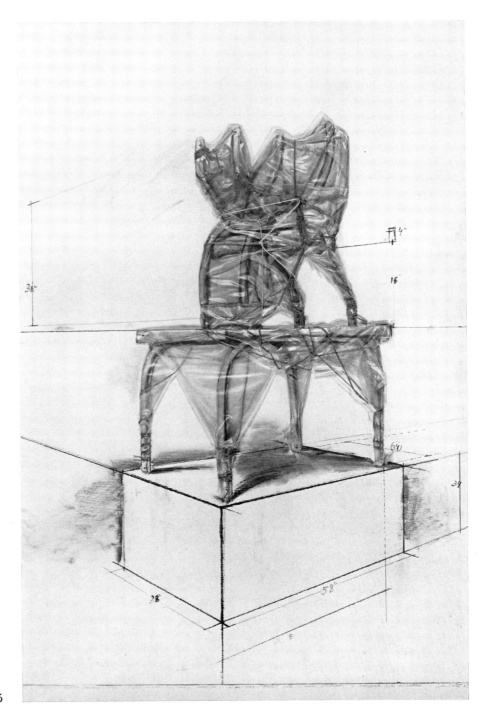

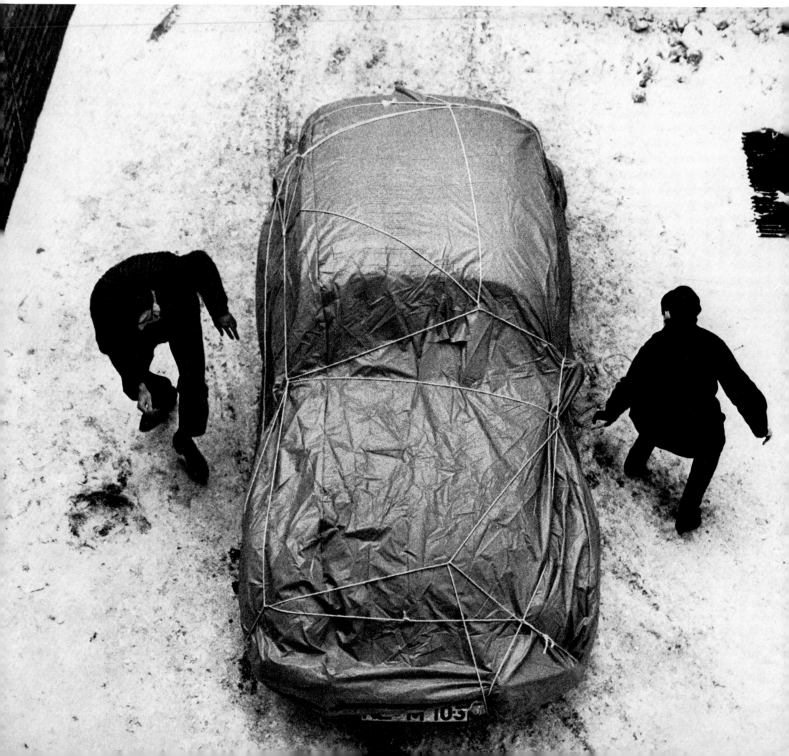

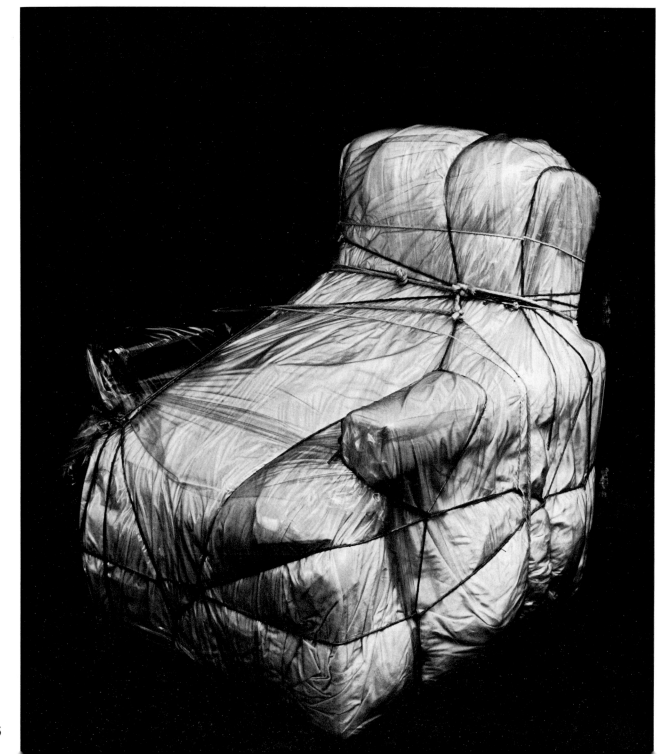

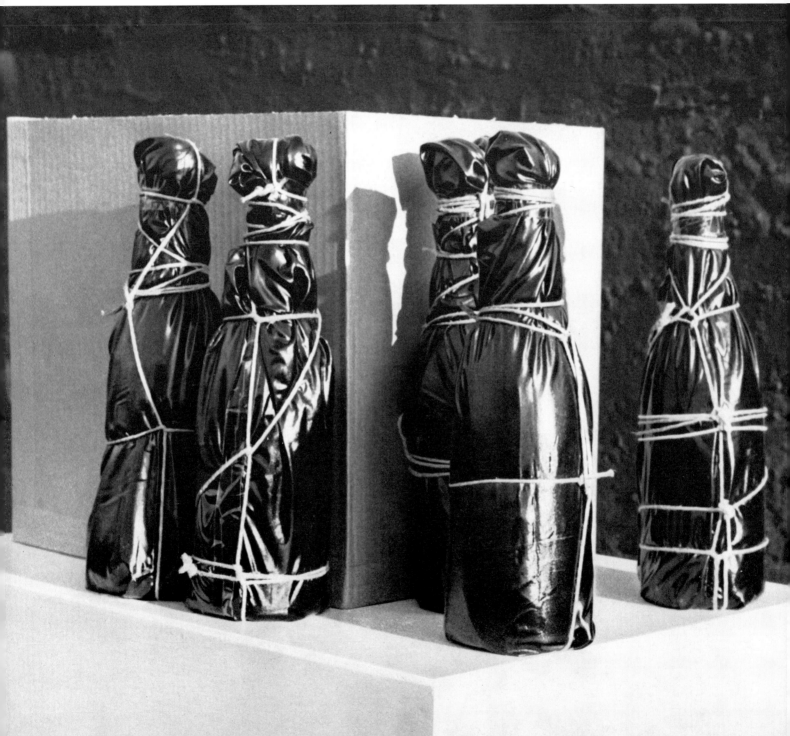

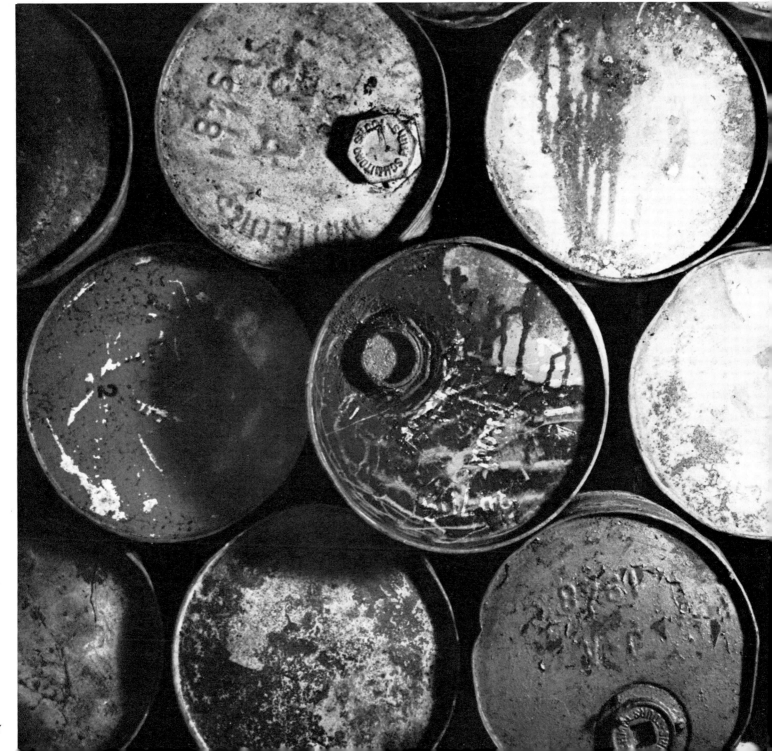

28

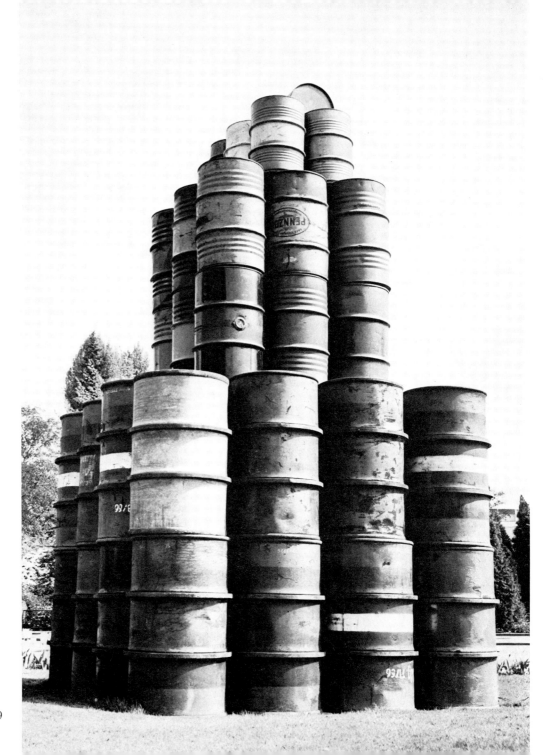

Project for a Temporary Wall of Metal Drums (rue Visconti, Paris VIe)

Between the Rue Bonaparte and the Rue de Seine, is the Rue Visconti, a one-way street, 176 metres long with an average width of 4 metres. The street ends at number 25 on the left side and at 26 on the right. It has a few shops: a bookstore, a modern art Gallery, an antique shop, an electrical supply shop, a grocery store. "...At the angle of Rue Visconti and the Rue de Seine, the cabaret du Petit More (or Maure) was opened in 1618. The poet Saint-Amant, who used to go there often, died there. The art gallery that now stands on the site of the tavern has fortunately retained the facade and the seventeenth-century sign." (p. 134, Rocheguide/Clebert, *Promenades dans les rues de Paris, Rive Gauche*, Editions Denoil.)
The wall will be built between numbers 1 and 2, completely closing the street to traffic, and will cut all communication between Rue Bonaparte and Rue de Seine.
Constructed solely with drums used for transporting gas and oil (different trade labels, like ESSO, TOTAL, SHELL, BP, of 50 or 200 litres capacity) the wall will be 4 metres high, 3.20 metres wide; 10 drums of 50 litres or 5 drums of 200 litres capacity will consitute the base. 150 drums of 50 litres or 80 drums of 200 litres are necessary for the execution of the wall.
This *iron curtain* can be used as a barricade during a period of public work in the street, or can be used to transform the street into a dead end. Finally its principle can be extended to a whole quarter or to a whole city.

Paris, October 1961

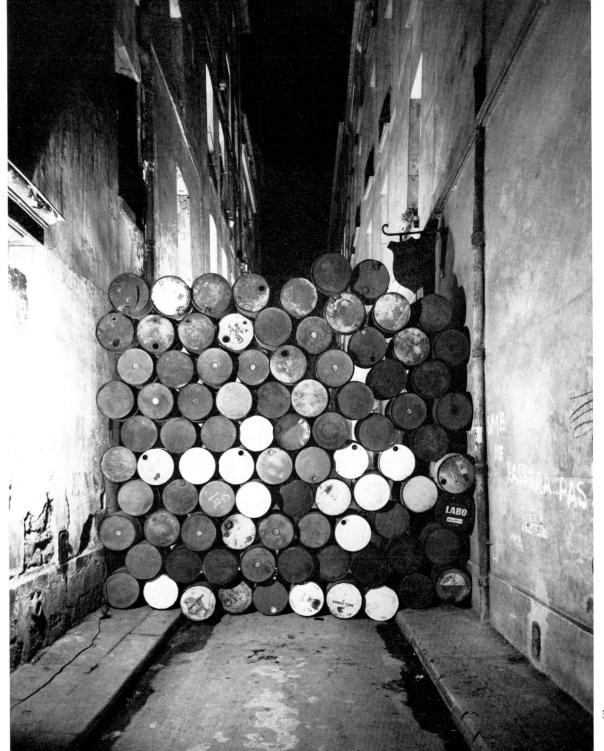

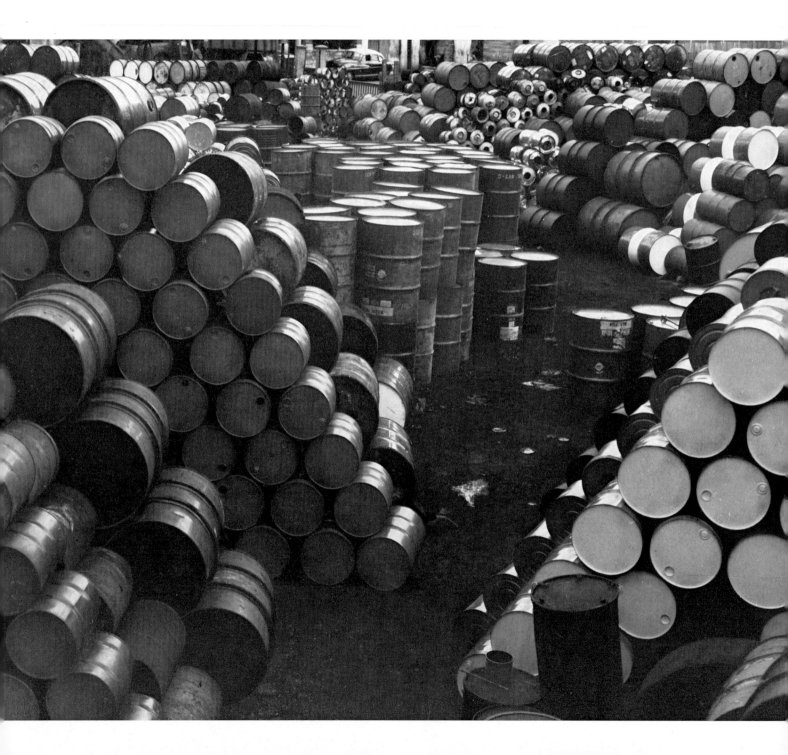

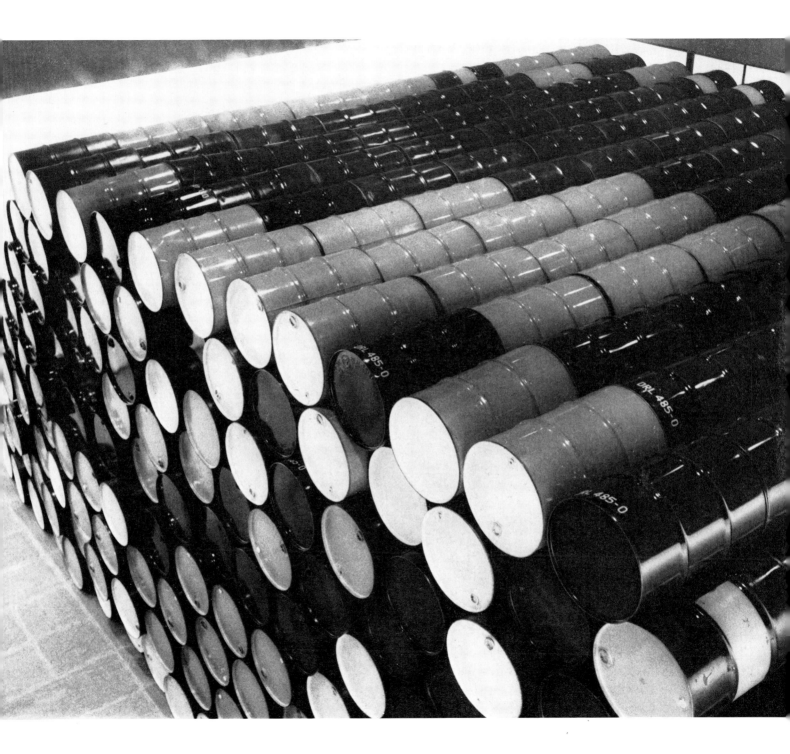

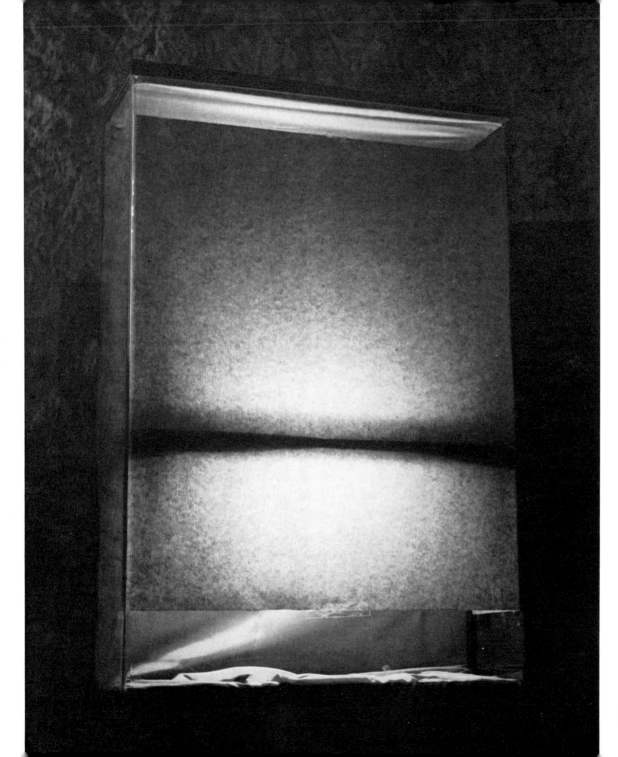

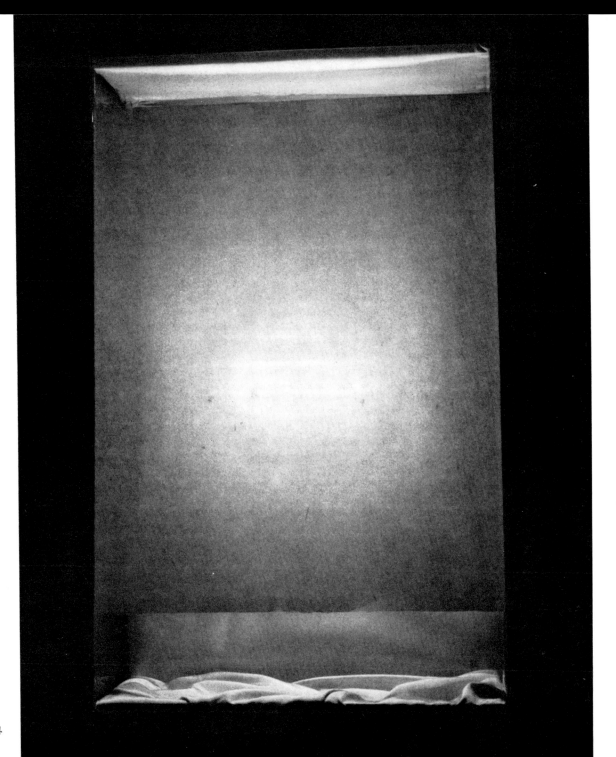

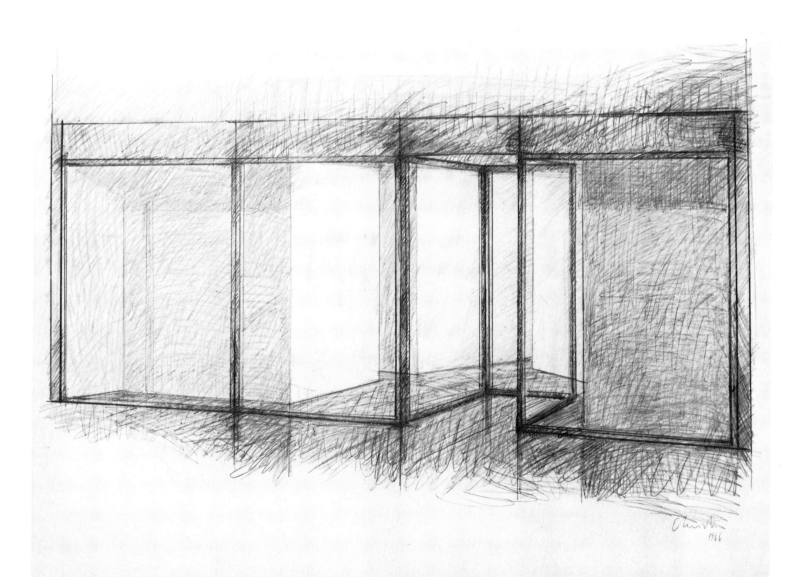

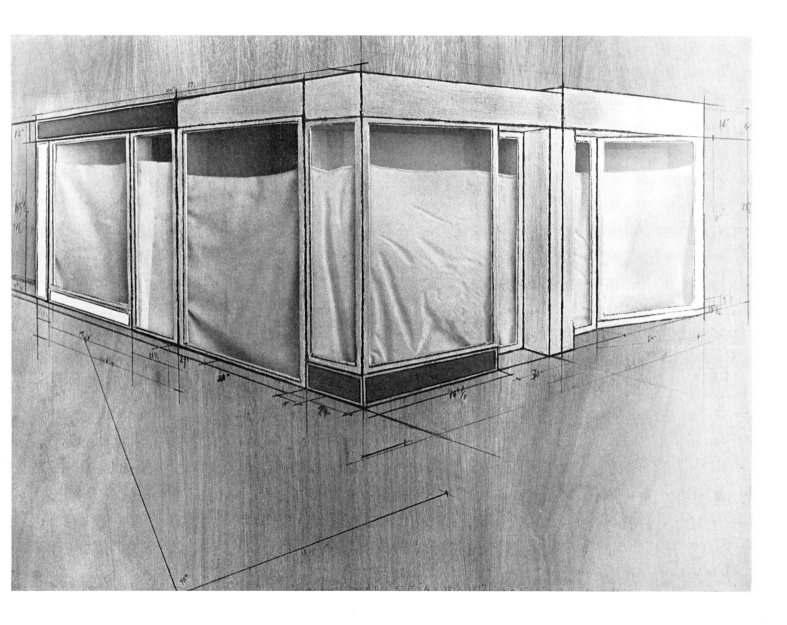

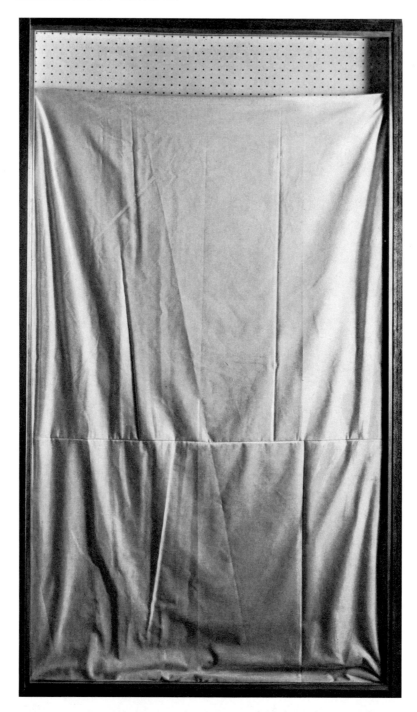

37

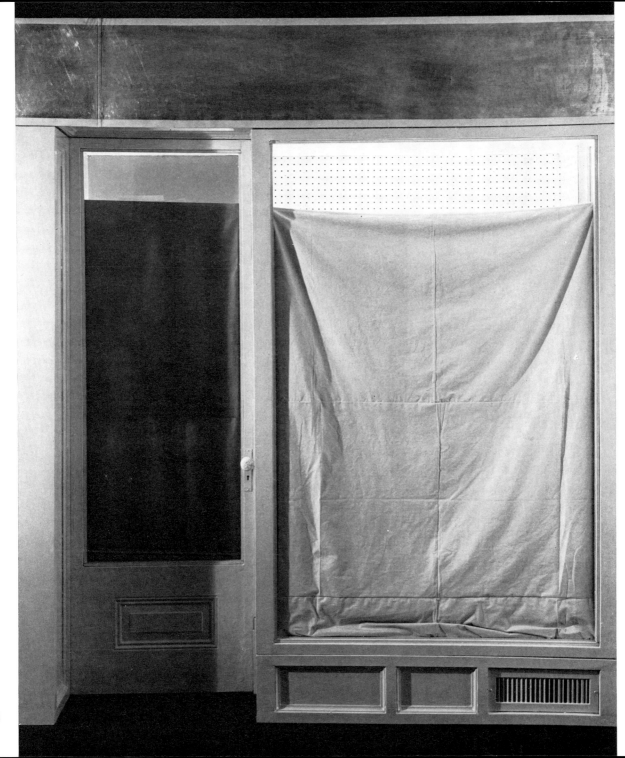

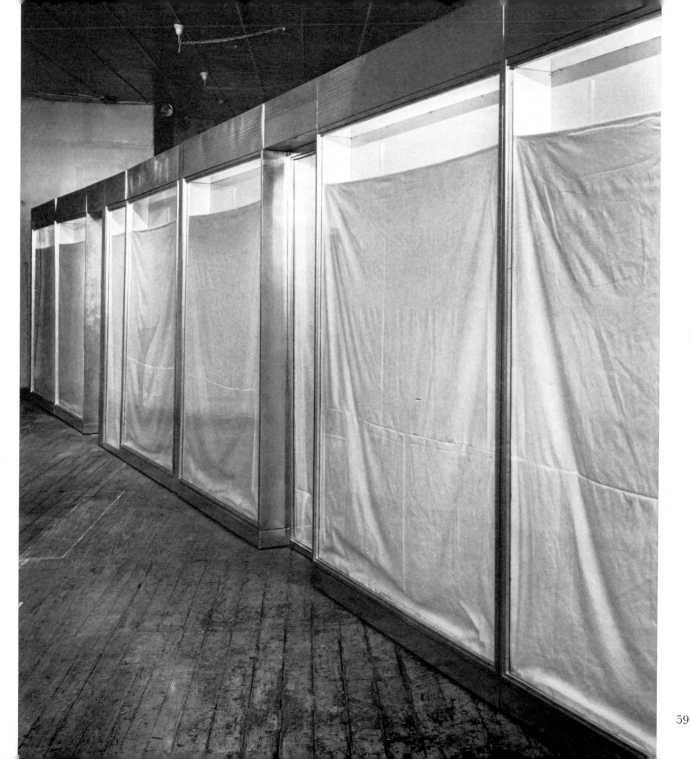

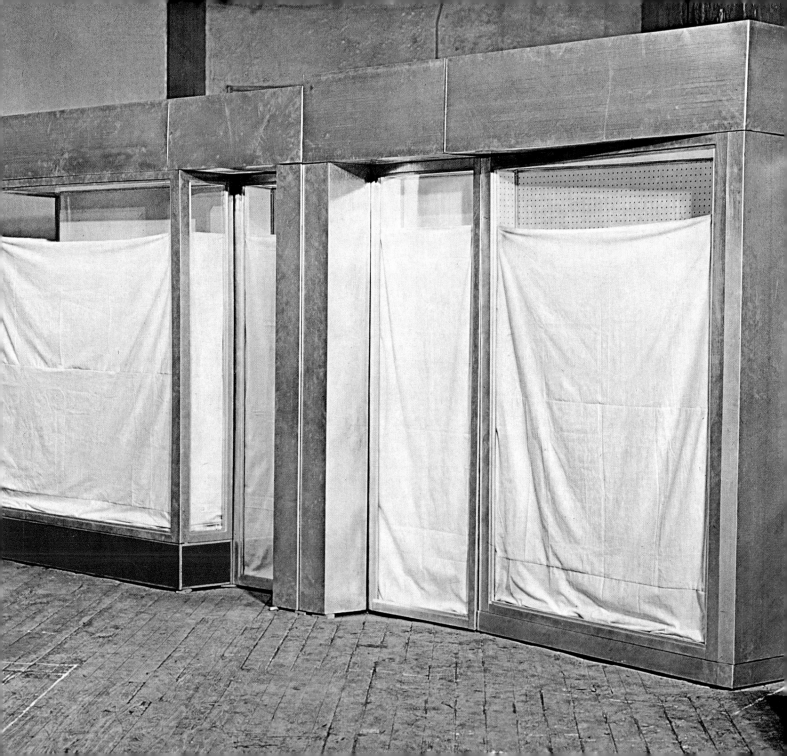

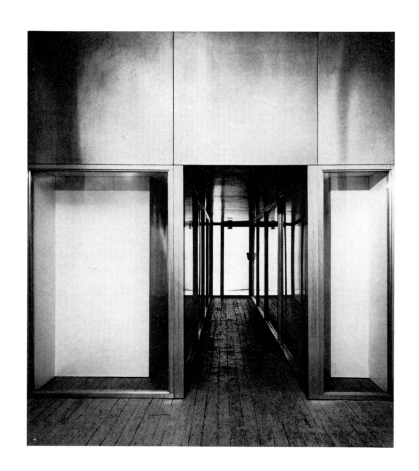

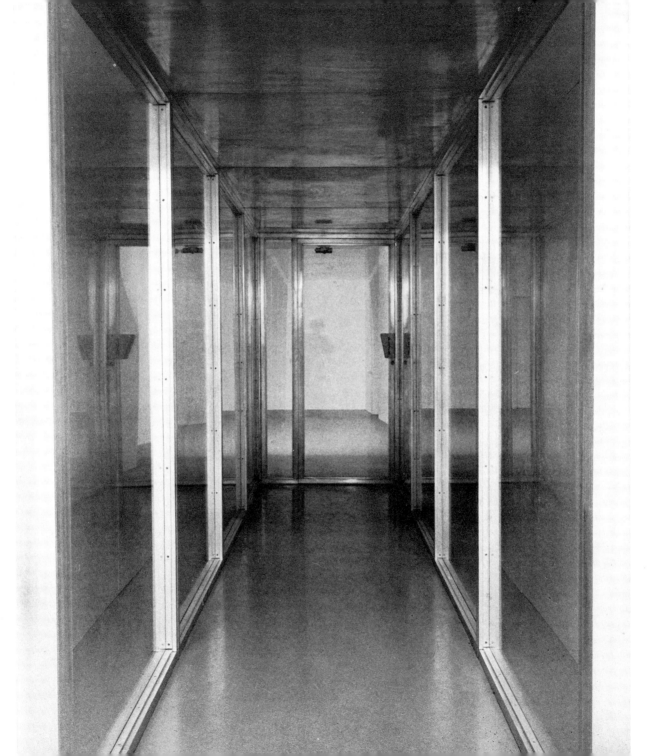

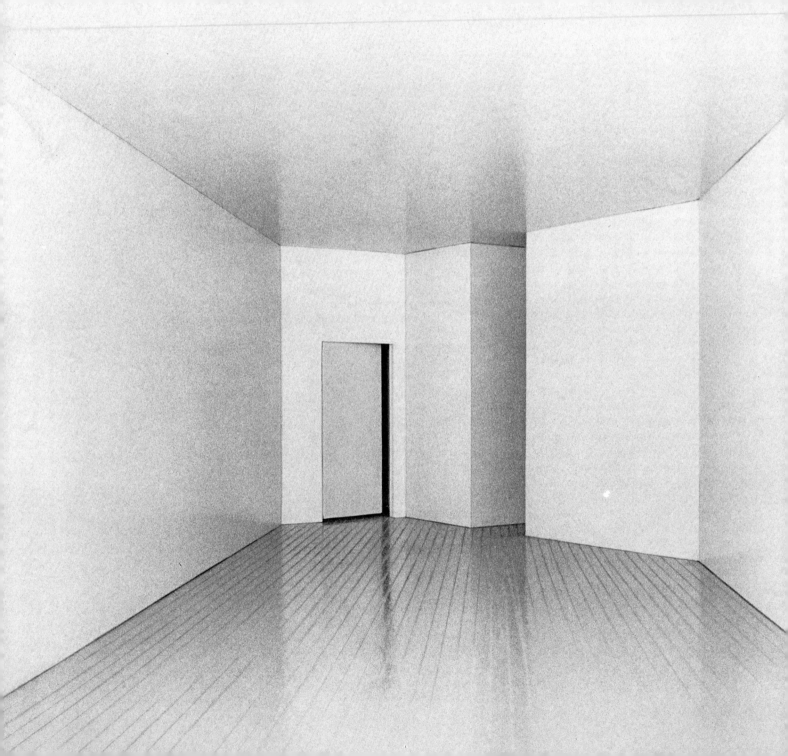

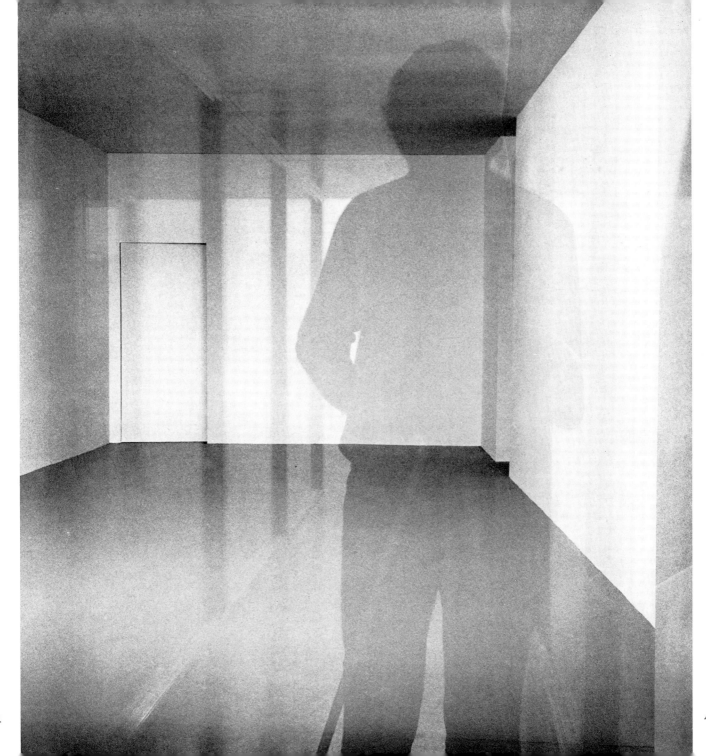

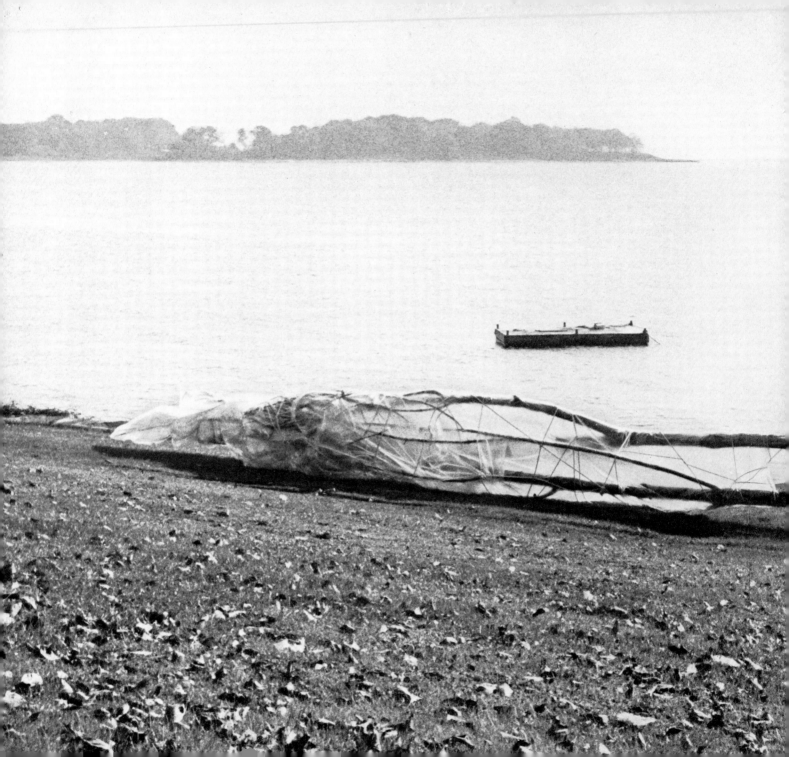

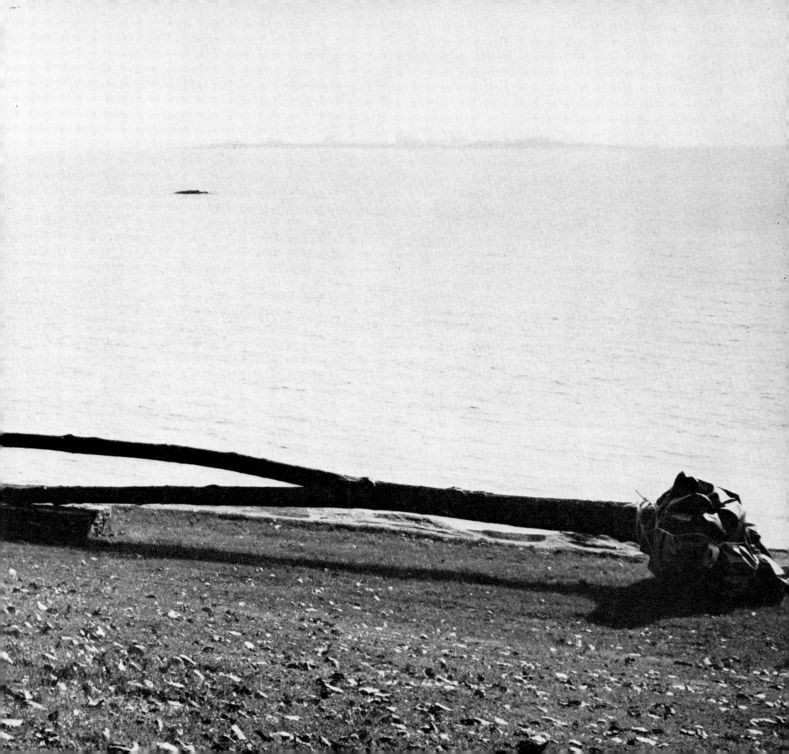

The building should be placed in a big, regular space.

The building should have a rectangular base without any façade. The building will be completely closed-up because packed on every side. The entrances will be underground, placed about 15 or 20 metres from the building.

The packing will be of rubberized tarpaulin and plastic material reinforced at average intervals of 10 or 20 metres by steel cables and ropes. With the steel cables we can obtain the strong points needed for the packaging of the building.

To achieve this, about 10,000 metres of tarpaulin, 20,000 metres of steel cables or ropes and 80,000 metres of ordinary ropes will be needed. The packed public building can be used as:

1. Stadium with swimming pools, football field, Olympic stadium or hockey and ice-skating rink.
2. Concert hall, conference hall, planetarium or experimental hall.
3. Historical museum, of recent or modern art.
4. Parliament or prison.

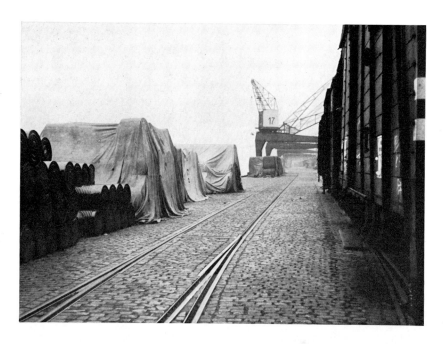

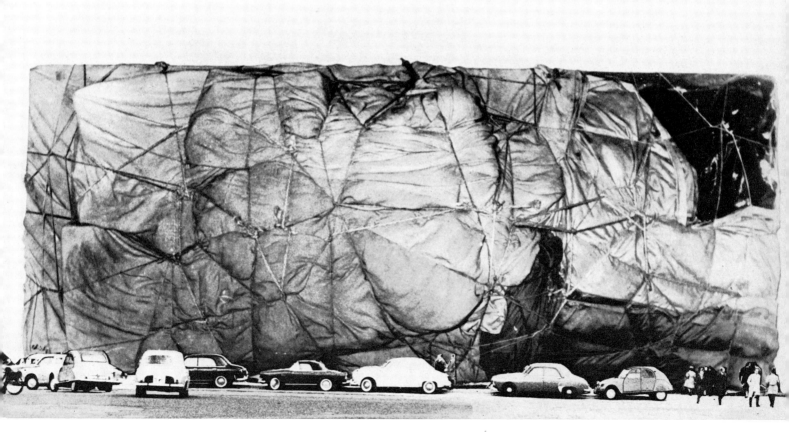

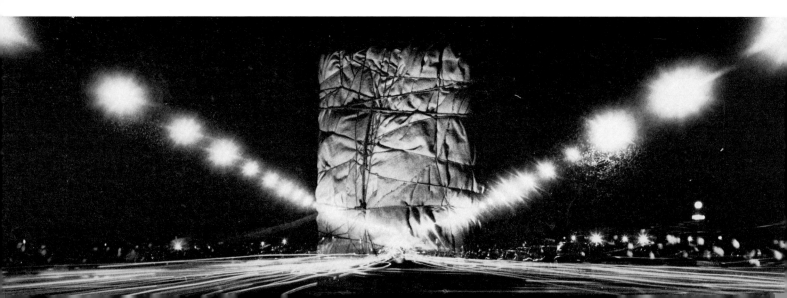

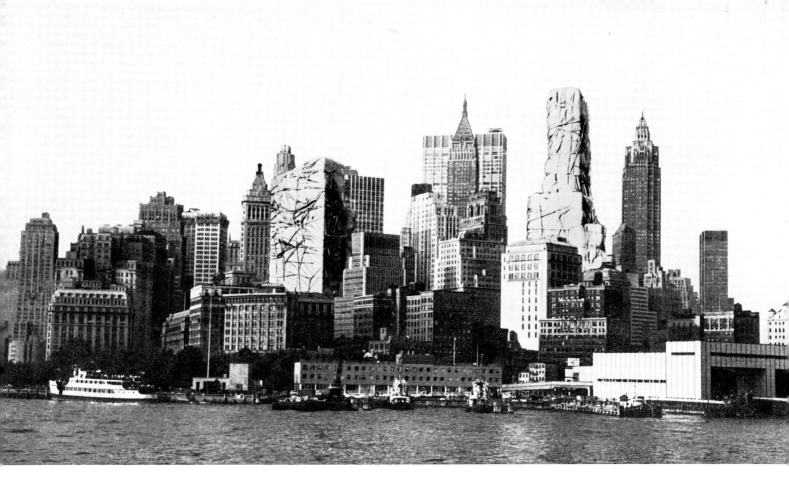

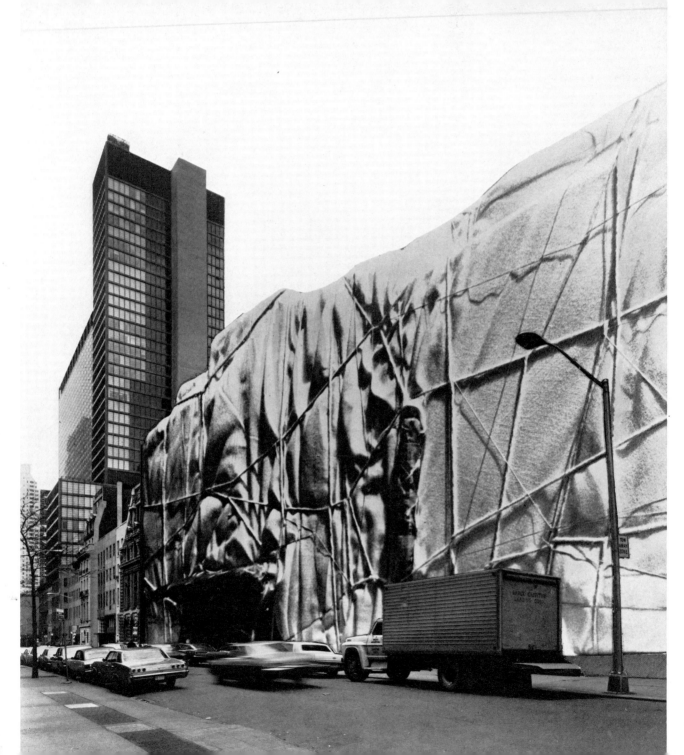

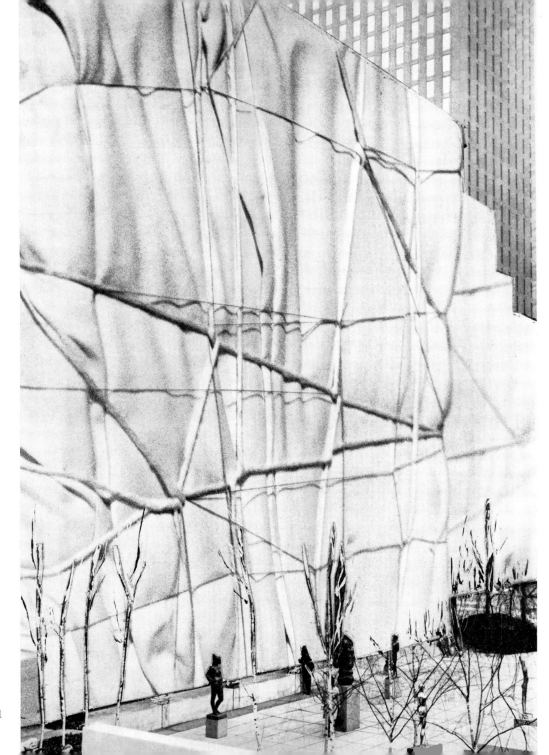

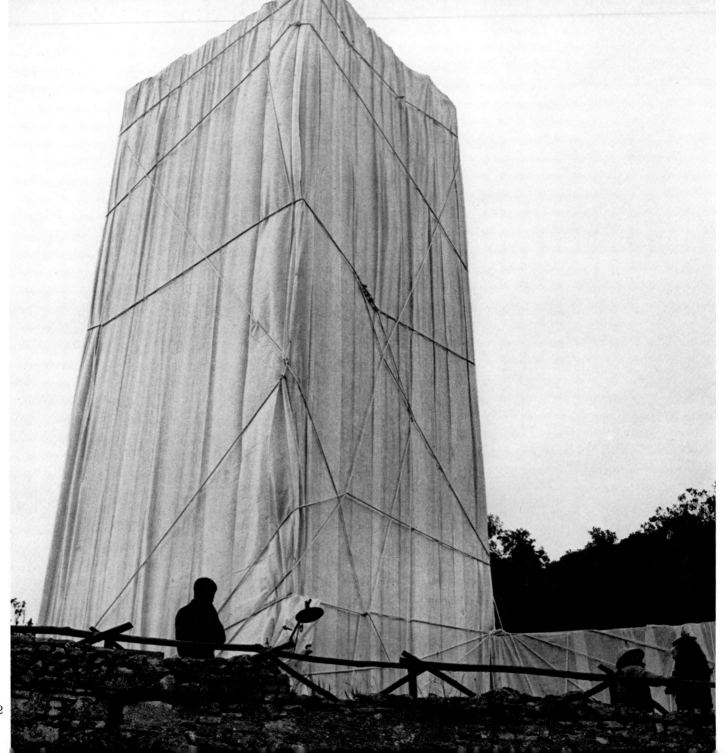

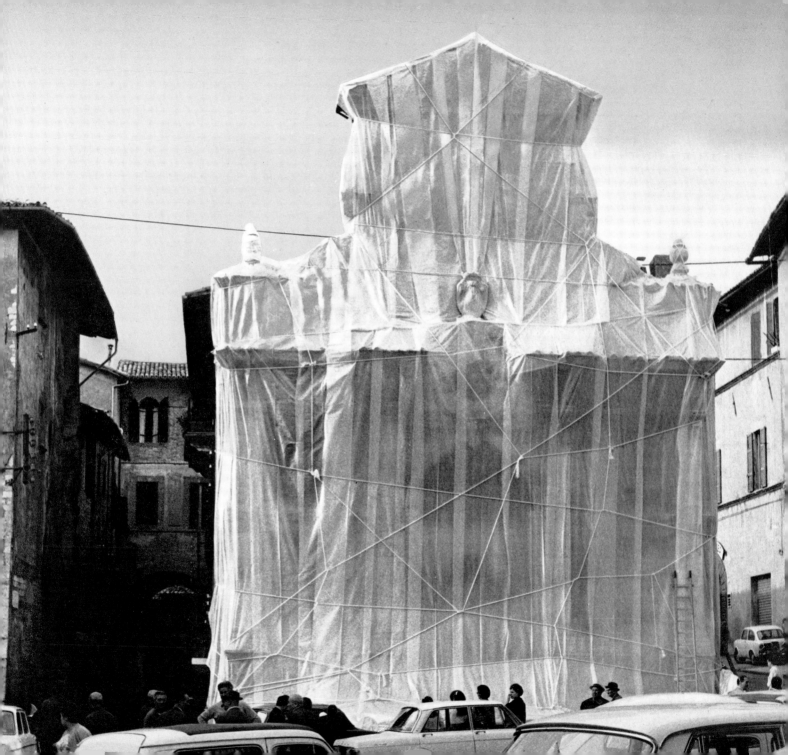

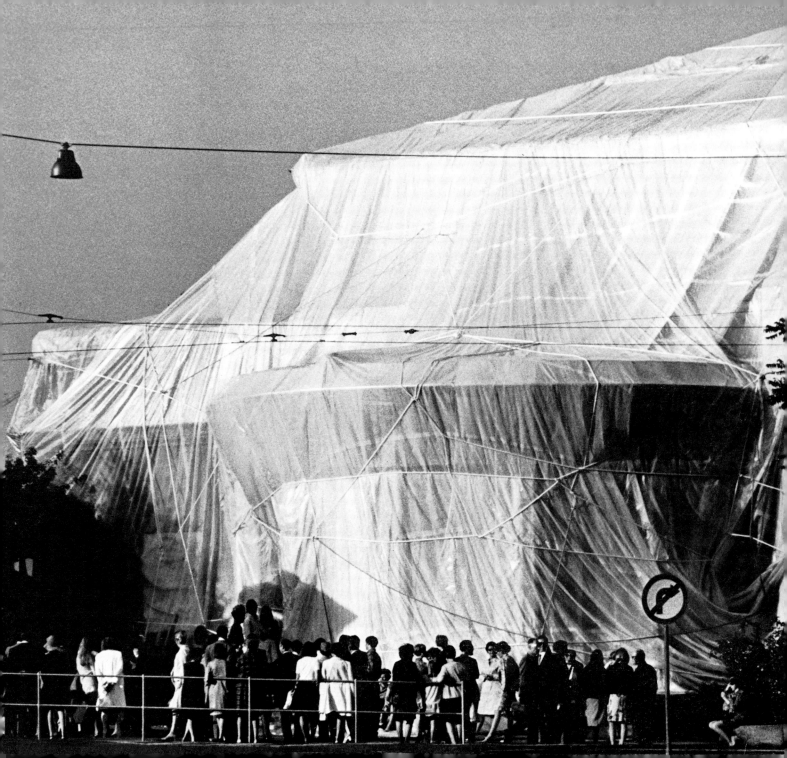

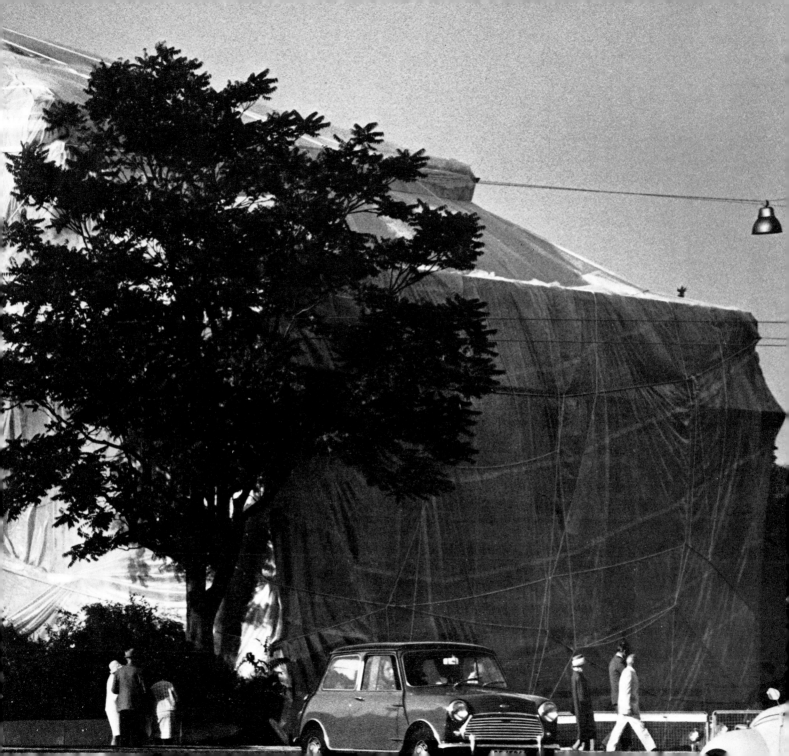

55, 56

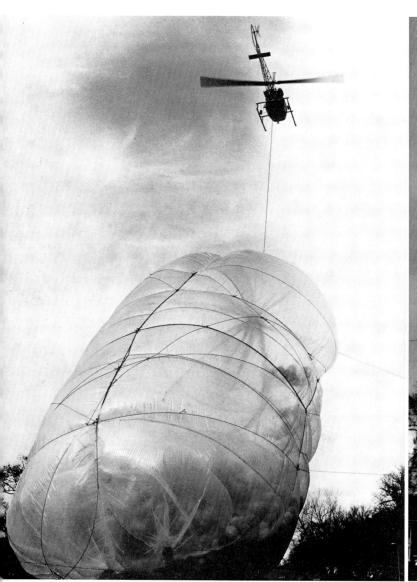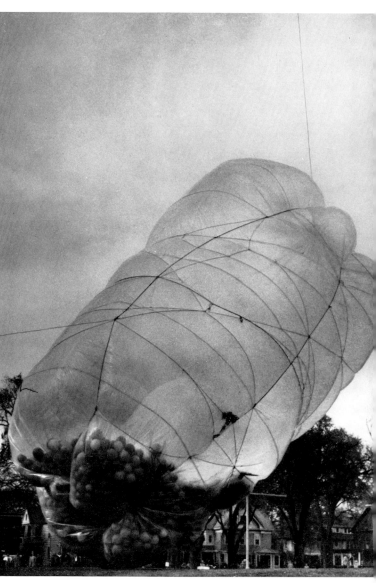

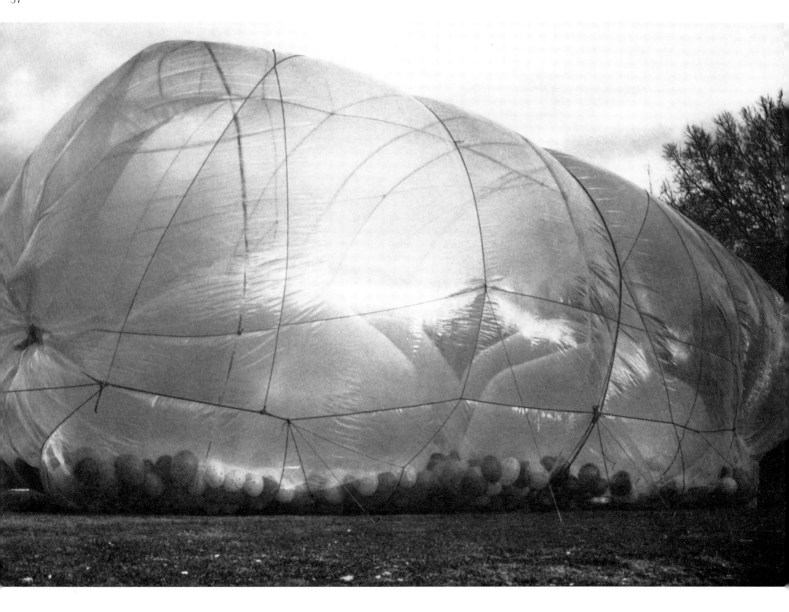

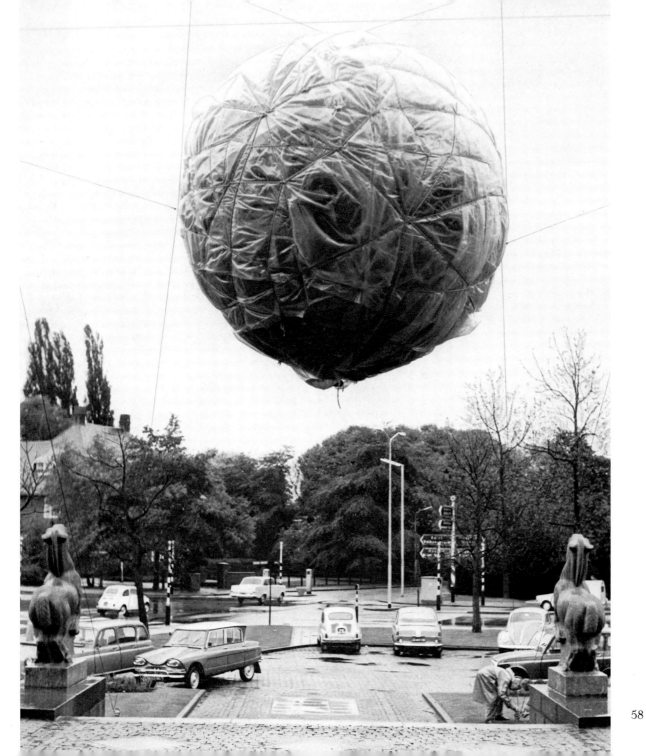

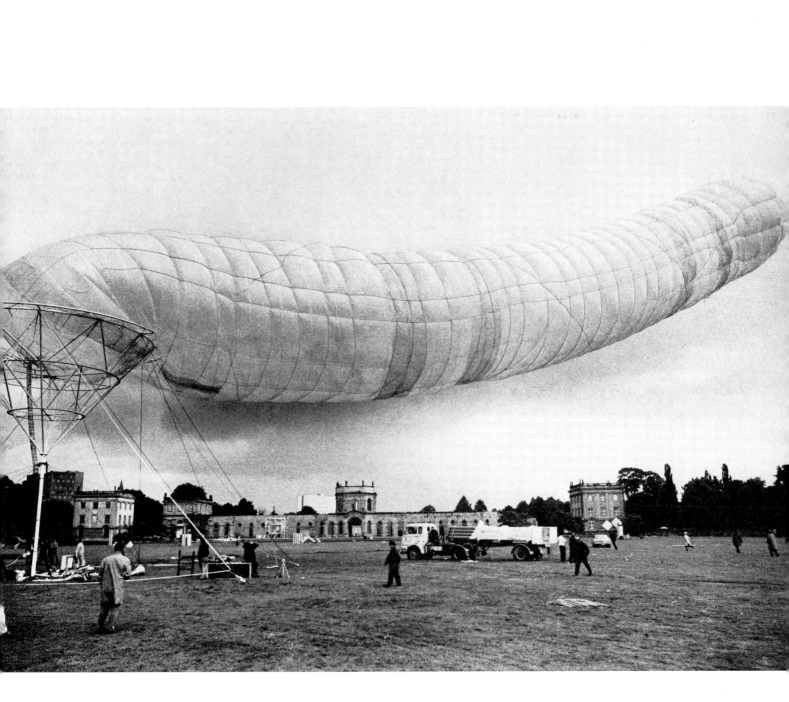

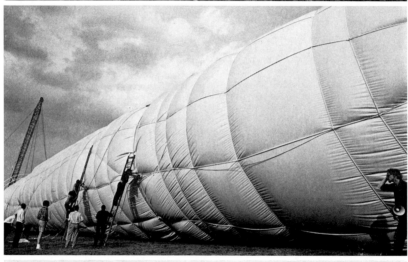

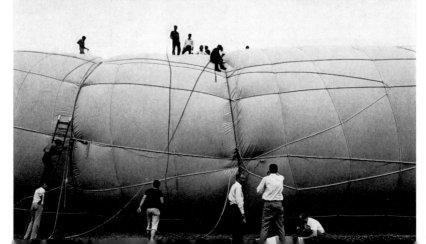

60-62

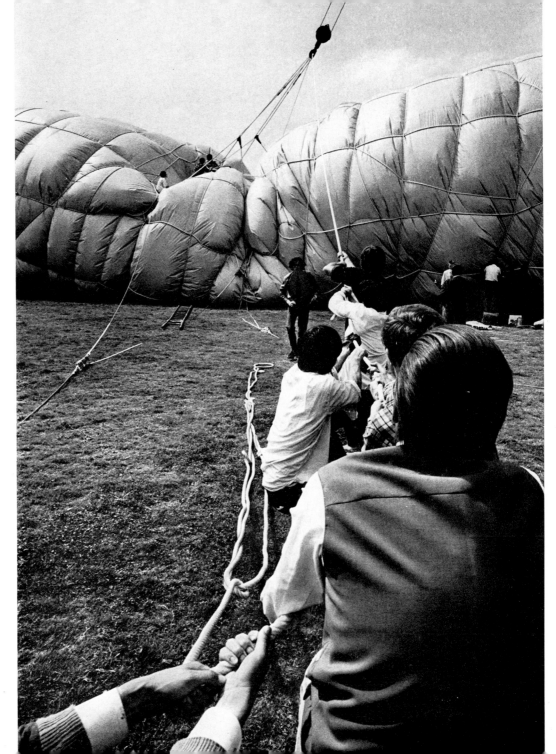

63

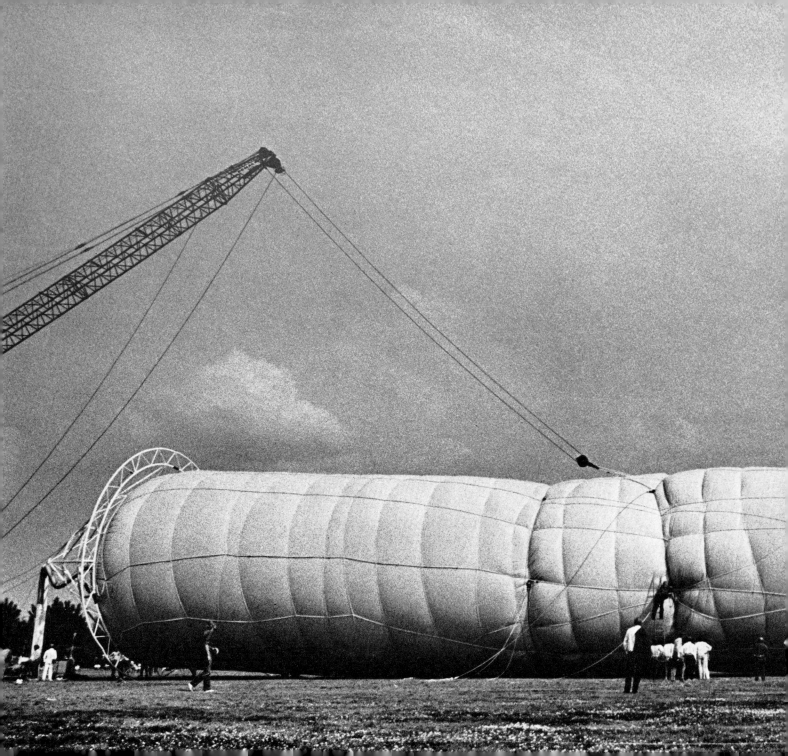

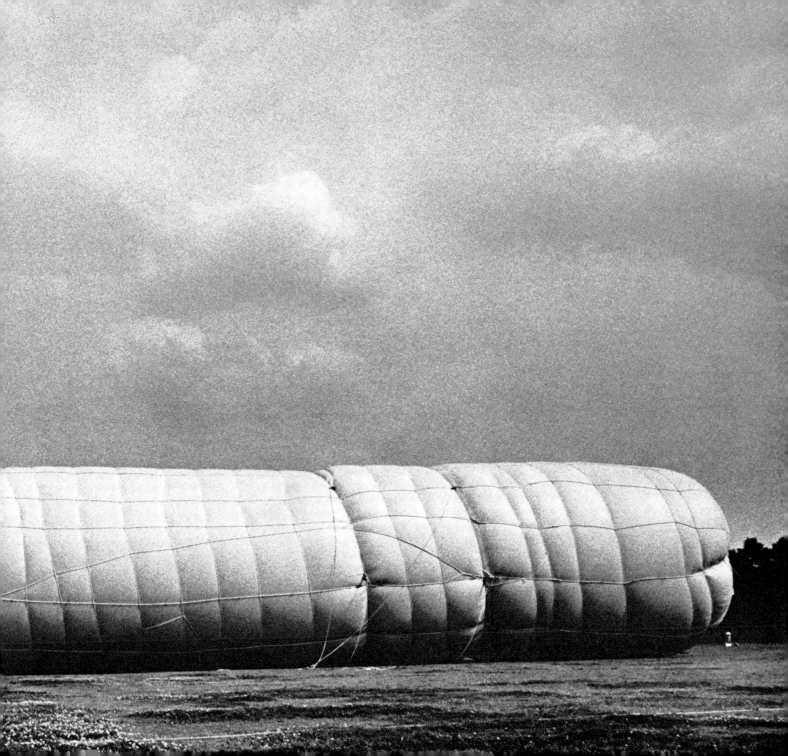

65-68

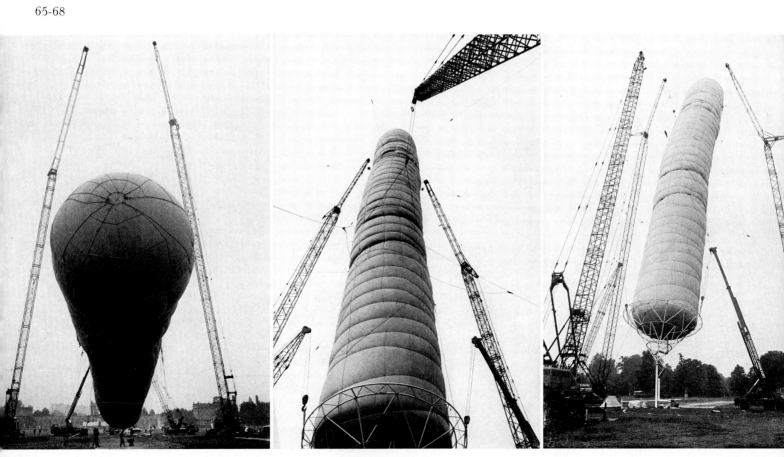

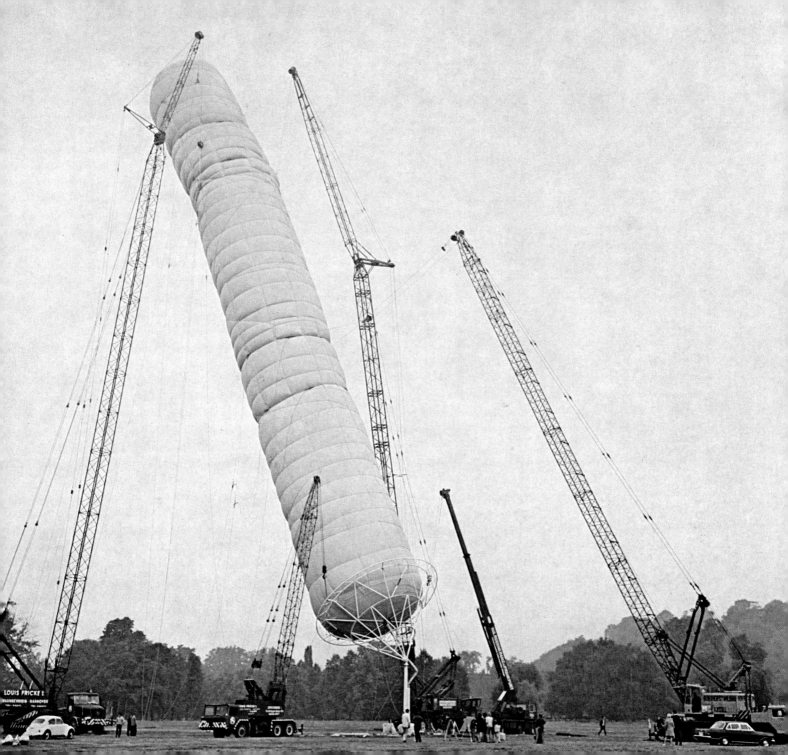

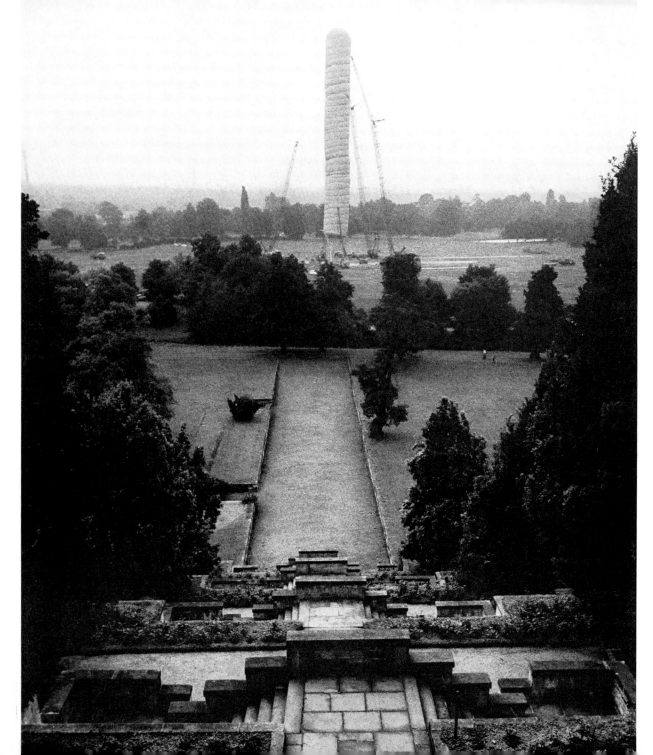

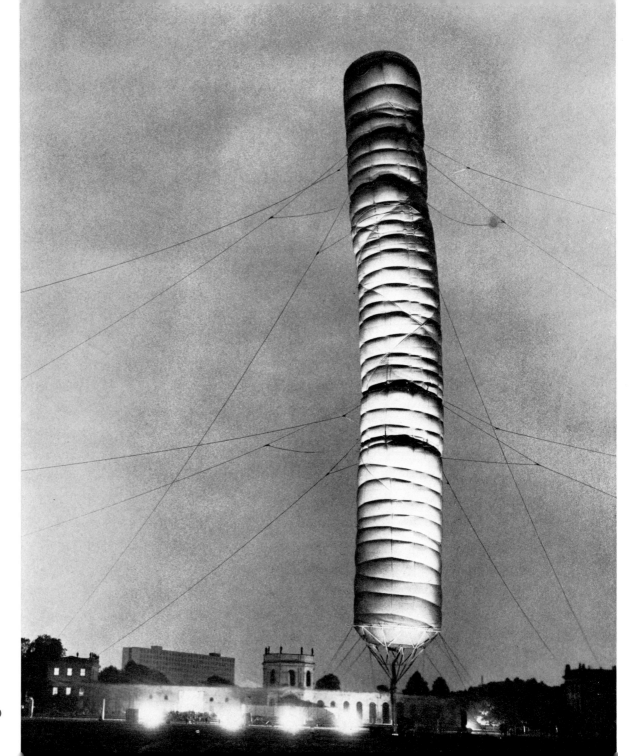

70

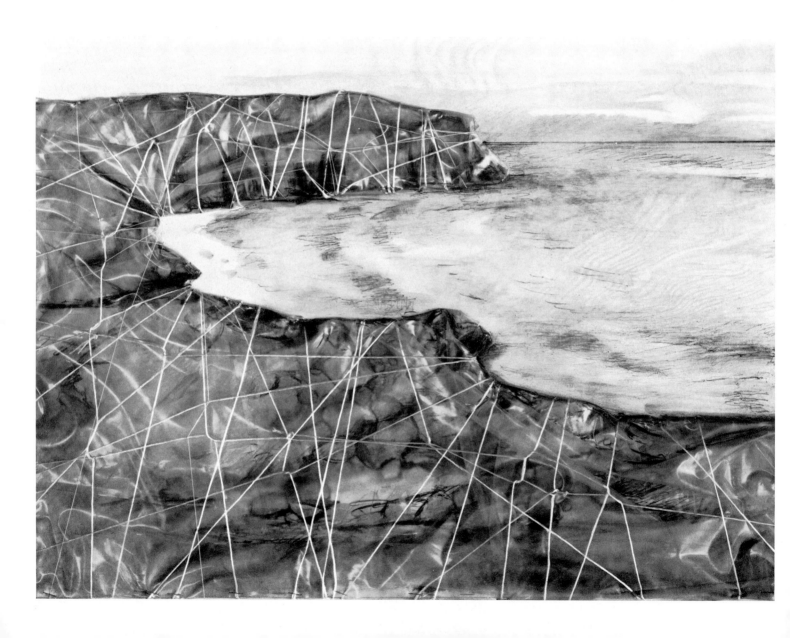

List of plates

1 Packed bottles and cans, 1958. 11 × 29 × 11$^1/_2$″. Collection J.C.C., New York
2 Package, 1960. 5′ × 8′ × 13″
3 Package, 1961. 36$^1/_2$ × 26 × 12″. Private collection, Antwerp
4 Two packed chairs, 1961. 35$^1/_2$ × 17 × 18$^1/_2$″
5 Packed table, 1960. 47$^1/_4$ × 32 × 15″
6 Packed table, 1961. 48 × 21$^3/_4$ × 16$^1/_2$″. Private collection, Antwerp
7 Packed table, 1961. 54 × 16$^1/_2$″. Collection D. Varenne, Paris
8 Packed motorcycle, 1962. 30$^1/_4$ × 76 × 16″
9 Packed road signs, 1963. 67 × 24$^1/_2$ × 21$^1/_4$″
10 Packed bicycle on luggage rack, 1962. 60 × 40$^1/_4$ × 12$^1/_4$″. Collection F. Becht, Hilversum
11 Package on wheelbarrow, 1963. 35 × 60 × 23″. The Museum of Modern Art, New York
12 Dockside package, 1961. 16 × 32 × 6′
13 Dolly, 1964. 72 × 40 × 24″
14–21 Packaging a girl, 1963.
22 Packed tree, 1964–65. Project, 24 × 29″. Collection Dr Sanders, Amsterdam
23 Packed chairs and table, 1965. Project, 48 × 29″. Collection John Powers, New York
24 Packed Volkswagen, 1963. 58$^1/_4$ × 161$^1/_2$ × 58$^1/_4$″
25 Packed armchair, 1965. 38 × 31$^1/_4$ × 32″
26 9 packed bottles, 1966. 13$^1/_4$ × 14 × 11″. Collection H. Rivera, New York
27 Oil drums (detail), 1962. 24″ diameter each barrel
28 Barrel-Tower, 1961. 15′ × 30″ × 30″
29 56 barrels, 1966–68. 16$^1/_2$ × 8 × 8′. Collection Mia and Martin Visser, Bergeyk, Holland
30 Barrel wall (erected in the Rue Visconti, Paris, on 27 June 1962). 164 × 158 × 32″
31 Temporary barrel monument, 1961. 60 × 75 × 9′
32 1240 oil drums, 1968. 21 × 30 × 40′. Institute of Contemporary Art, Philadelphia

33 Showcase, 1963. 30 × 20 × 8"

34 Showcase, 1963. 30 × 20 × 8"

35 Corridor store front, 1966. Project, 22 × 29". Collection Dominique and John de Menil, New York

36 4 store fronts, 1964–65. Project, 33 × 48 × 3". Collection Harry N. Abrams, New York

37 Show window, 1965–66. 84 × 48 × 4". Collection Ch. Vowinckel, Cologne

38 Yellow store front, 1965. 98 × 88$^1/_4$ × 16". Collection Mr and Mrs H. Solomon, New York

39 3 store fronts, 1965–66. 8' × 46' × 17"

40 4 store fronts corner, 1964–65. 36" × 7$^3/_4$' × 24"

41 Corridor store front, 1966–67. App. 1500 square feet. Private collection, Antwerp

42 Corridor store front, 1966–67. App. 1500 square feet. Private collection

43 Corridor store front—interior view, 1967. Project, 24 × 15$^3/_4$ × 48"

44 Corridor store front—interior view, 1967–68. App. 1500 square feet. Private collection, Antwerp

45 Packed tree, 1968. 58' long. Collection Mr and Mrs A. List, Byram, Connecticut

46 Dockside packages and stacked oil drums, temporary monument, installation view, Cologne/Harbor, 1961.

47 Packed public building, Paris, 1961. Collaged photographs, 7 × 9$^1/_2$"

48 Packed public building, 1963. Collaged photographs, 13 × 36"

49 Two Lower Manhattan packed buildings, 1964–66. Collaged photographs, 20$^1/_2$ × 29$^1/_2$". Collection Mr and Mrs H. Solomon, New York

50 The Museum of Modern Art, packed, 1968. Collaged photographs (detail), 10 × 16". The Museum of Modern Art, New York (Gift from Dominique and John de Menil)

51 The Museum of Modern Art, packed, 1968. Collaged photographs, 10 × 7"

52 Packed tower, Festival of Two Worlds, Spoleto, 1968. 82 × 24 × 24'

53 Packed fountain, Festival of Two Worlds, Spoleto, 1968. 46' high

54 Kunsthalle Bern, packed, 1968. 27,000 square feet

55–57 42390 cubic feet package, 1966. 60′ high, 21′ diameter. Minneapolis School of Arts – Walker Art Centre, Minneapolis, Minnesota

58 Air package, Volume temporale, 1966. 17′ diameter. Stedelijk van Abbemuseum, Eindhoven, Holland

59–70 5600 cubic metres package, Kassel, 4. documenta, 1967–68. 280′ high, 33′ diameter

71 Packed coast, project for west coast, 15 miles long, 1968. 24 × 29″. Gerd Hatje, Stuttgart

Biography

1935	Christo Javacheff, born June 13 in Gabrovo, Bulgaria
1951–1956	Study at Fine Arts Academy, Sofia
1956	Work-study at the Burian Theatre, Prague
1957	One semester's study at the Vienna Fine Arts Academy
1958	Arrival in Paris. First packages and wrapped objects
1961	First project for the packaging of a public building. Stacked oil drums and dockside packages in Cologne/Harbor. Association with Nouveau Réalisme
1962	"Iron Curtain" wall of oil drums set up in the rue Visconti, Paris. Stacked oil drums in Gentilly near Paris
1963	First showcases
1964	Establishment of permanent residence in New York. First store front
1966	First air package: Stedelijk van Abbemuseum, Eindhoven, Holland. 42390 cubic feet package: Walker Art Centre, Minneapolis School of Arts, Minneapolis, Minnesota
1968	Packed fountain and packed medieval tower in Spoleto. First packaging of a public building: Kunsthalle Bern, Switzerland. 5600 cubic metres package created for documenta 4 in Kassel, Germany, an air package 280 feet in height, 33 feet in diameter, supported by 6 concrete foundations arranged in a circle of 900 feet in diameter. Corridor store front with a total area of 1500 square feet. Project for a packed coast. 1240 oil drums: Philadelphia Institute of Contemporary Art
1969	Museum of Contemporary Art, Chicago: packed. Wrapped ground: 2800 square feet of drop cloths, Museum of Contemporary Art, Chicago

Bibliography

1961 G.Weelen, Sens Plastique, XXVII, 1961

Pierre Restany, *Christo*. Essay in Exhibition Catalogue, Galerie Haro Lauhus, Cologne, June, 1961

S.Bonk, *Abgenütztes verhüllt sein zweites Gesicht*. Kölner Stadt-Anzeiger, July 31, 1961

M.Rotharmel, *Kunst tonnenweise gestapelt*. Kölnische Rundschau, August 3, 1961

1962 Pierre Restany, *Christo*. Essay in Exhibition Catalogue, Galerie J, Paris, June, 1962

Pierre Restany, *Christo*. Cimaise, no. 60, p. 98, July, 1962

Michel Ragon, *Nouvelles défigurations*. Arts-Lettres-Spectacles, July 11, 1962

Jean-Jacques Levèque, *Les expositions à Paris*. Aujourd'hui, no. 38, p. 52, September, 1962

Michel Ragon, *Le new look de la jeune peinture*. Arts-Lettres-Spectacles, December 5, 1962

1963 Georges Boudaille, *L'avant-garde a-t-elle un sens?* Les lettres françaises, January, 1963

Michel Ragon, *Bilan 1962*. Arts-Lettres-Spectacles, January, 1963

Pierre Restany, *Le nouveau réalisme und was darunter zu verstehen ist*. Das Kunstwerk, 7/XVI, January, 1963

Herta Wescher, *What is New with the New Realists?* Cimaise, no. 64, p. 30–51, March, 1963

Michel Ragon, *Le Nouveau Réalisme*. Jardin des Arts, March, 1963

Pierre Restany, *Un giovane neo-realista a Parigi*. Domus, no. 402, p. 52–6, May, 1963

Dino Buzzati, *Pacchi di Christo*. Corriere d'informazione, June 26–27, 1963

M.Valsecchi, *Christo fra i pacchi*. Il Giorno, July 14, 1963

Pierre Restany, *Christo*. Essay in Exhibition Catalogue, Galleria Apollinaire, Milan, November, 1963

Luigi Locatelli, *Un bel pacco con dentro un'indossatrice*. Il Giorno, November 7, 1963

V.Rubiu, *Christo alla Galleria Salita di Roma*. Collage, no. 1, p. 7, December, 1963

1964 Michel Ragon, *Naissance d'un Art Nouveau*. Edition Albin Michel, Paris, 1964

Jasia Reichardt, Pierre Restany, W.A.L.Beeren, Essays in Exhibition Catalogue "Nieuwe Realisten". Gemeente Museum, The Hague, 1964

Giorgio di Marchis, *Cronaca di Roma: Christo*. Art International, VIII/1, p. 54, February, 1964

Silvio Branzi, *Notizie di Venezia*. Art International, VIII/1, p. 27, February, 1964

Pierre Restany, *L'art fantastique, après l'art abstrait quoi?* Planète, March 21, 1964

Pierre Restany, *Pop-Art Diskussion: Pop-Art, Neo-Dada, Nouveau Réalisme*. Das Kunstwerk, 10/XVII, p. 30, April, 1964

Brian O'Doherty, *The Season Ends*. The New York Times, May 31, 1964

Bruno Alfieri, *Christo*. Pacco, no. 2–3, September, 1964

Donald Judd, *Exhibition at Castelli Gallery*. Arts Magazine, 10/38, p. 69, September, 1964

1965 Jürgen Becker, *Happenings, Fluxus, Pop Art*. Rowohlt Paperback, Sonderband, Reinbek bei Hamburg, 1965

Rolf-Gunter Dienst, *Pop Art*. Limes Verlag, Wiesbaden, 1965

Harold Rosenberg, *The Anxious Object*. Horizon Press, New York, 1965. Thames and Hudson, London, 1966

Marvin Elkoff, *The Left Bank of the Atlantic*. Show, April, 1965

Otto Hahn, *Christo's Packages*. Art International, IX/3, p. 25–7, April, 1965

Otto Hahn, *Avant-garde Stance*. Arts Magazine, no. 39, p. 24, May-June, 1965

Lil Picard, *Exhibition at Leo Castelli Gallery*. Das Kunstwerk, 5–6, XIX, p. 59, November 1965

1966 Aldo Pellegrini, *New Tendencies in Art*. Crown Publishers, New York, 1966

David Bourdon, Otto Hahn, Pierre Restany, *Christo*. Edizioni Apollinaire, Milan, 1966

Lucy Lippard, ed., *Pop Art*. Frederick A. Praeger, New York, 1966. Thames and Hudson, London, 1966

Lawrence Alloway, *Christo*. Essay in Exhibition Catalogue, Stedelijk van Abbemuseum, Eindhoven, Holland, 1966

Martin Friedman, Jan van der Marck, Essays in Exhibition Catalogue "Eight Sculptors: The Ambiguous Image". Walker Art Centre, Minneapolis, Minnesota, 1966

P.B.M. Panhuysen, *Christo*. Museumjournaal, Series 11, no. 6, 1966

M. Visser, *Christo*. "md" – Möbel Interior Design, no. 1, January, 1966

Udo Kultermann, *Die Sprache des Schweigens*. Quadrum, no. 20, p. 7–30, January, 1966

Pierre Restany, *Les Store-Fronts de Christo: Une architecture-sculpture du Nouveau Réalisme*. Domus, no. 435, p. 45–9, February, 1966

David Bourdon, *Christo's Store Fronts*. Domus, no. 435, p. 49, February, 1966

Otto Hahn, *Lettre de Paris...et Eindhoven*. Art International, X/7, p. 66–8, September, 1966

David Bourdon, *Christo*. Art and Artists, p. 50, October, 1966

Peter Schjeldahl, *Christo*. Art News, June, 1966

1967 Pierre Restany, *Le Nouveau Réalisme*. Edition Planète, Paris, 1967

C. Linfert, Pierre Restany, Exhibition Catalogue "Premio Marzotto". Stedelijk Museum, Amsterdam, 1967

Emily S. Rauh, Exhibition Catalogue "7 for 1967". St Louis City Art Museum, St Louis, Missouri, 1967

Jean-Jacques Levèque, *L'art trahi par les peintres*. Art-Loisirs, no. 77, 1967

Dan Graham, *Models and Monuments*. Arts Magazine, 41/5, p. 32–5, March, 1967

Jan van der Marck, *Minneapolis Package*. Domus, no. 448, p. 50–3, March, 1967

R. Melville, *Marzotto Prize Exhibition at the Tate: the impact of the urban scene on creative thought*. The Architectural Review, no. 142, p. 215, September, 1967

Costantino Corsini, *Pneu: strutture pneumatiche*. Domus, no. 457, p. 18, Dec. 1967

1968 Michel Ragon, Gilbert Lascault, *Art et Contestation*. La Connaissance, Brussels, 1968

Udo Kultermann, *Nuove Dimensioni della Scultura*. Feltrinelli, Milan, 1968. English edition: *New Dimensions in Sculpture*. Thames and Hudson, London, 1968

R. Tröstel, M. Zagoroff, *Christo: 5600 Cubic Metres Package*. Wort und Bild, Munich, 1968

W. A. L. Beeren, Exhibition Catalogue "Three Blind Mice". Stedelijk van Abbemuseum, Eindhoven, 1968

William S. Rubin, Exhibition Catalogue "Dada, Surrealism and their Heritage". The Museum of Modern Art, New York, 1968

William S. Rubin, Foreword in Exhibition Catalogue "Christo Wraps the Museum". The Museum of Modern Art, New York, 1968

Exhibition Catalogue, "4. documenta". Kassel, Germany, 1968

Stephen S. Prokopoff, Exhibition Catalogue "Christo, Monuments and Projects". Institute of Contemporary Art, University of Pennsylvania, Philadelphia, 1968

Pierre Restany, Exhibition Catalogue "12 Environments". Kunsthalle Bern, 1968

Emily Genauer, *New Entries in the Highjinks Field*. Newsday, January, 1968

Lucy Lippard, John Chandler, *The Dematerialization of Art*. Art International, XII/2, p. 31–6, February, 1968

Petra Kipphoff, *Das Documenta-Ding*. Die Zeit, May 3, 1968

John Gruen, *Christo Wraps the Museum*. New York Magazine, June 24, 1968

Grace Glueck, *Documenta: it beats the Biennale*. The New York Times, July 7, 1968

Jan van der Marck, *Swinging Art Show in Old Museum*. Chicago Sunday Times, July 7, 1968

Christopher Kuhn, *Christo in New York*. Du, August, 1968

Jürgen Hohmeyer, *Christo: Leerer Laden*. Der Spiegel, August 12, 1968

Dino Buzzati, *Documenta*. Corriere della Sera, August 17, 1968

Franck Jotterand, *Un musée sous emballage*. Le Nouvel Observateur, August 26, 1968

David Bourdon, *Crisis of Christo's Balloon*. Life, September 6, 1968

Karl-Günter Simon, *Große Heuler in der Nacht*. Stern, September 8, 1968

Lawrence Alloway, *Christo and the New Scale*. Art International, September, 1968

Tommaso Trini, *Pneu-realtà. 5600 Cubic Metres Package*. Domus, no. 467, p. 50, October, 1968

Piri Halasz, *The Avant Garde*. Time, November 22, 1968

1969 Jan van der Marck, Exhibition Catalogue "Christo, Wrap In, Wrap Out". Museum of Contemporary Art, Chicago, 1969

Grégoire Muller, *The Art Scene in France*. Arts Magazine, December/January 1969

Geert Bekaert, *Gesprek met Christo*. Streven, January, 1969

Franz Schulze, *Why the Wrap-in?* Chicago Daily News, January 15, 1969

Piri Halasz, *All Package*. Time, February 7, 1969

Howard Junker, *Under Wraps*. Newsweek, February 10, 1969

Rosalind Constable, *The New Art*. New York Magazine, March 10, 1969

Stephen S. Prokopoff, *Christo*. Art and Artist, April, 1969

David Shirey, *Impossible Art*. Art in America, June, 1969

Bijutsu Techo, no. 6, Tokio, June 1969

L. Licitra, *Christo—New Projects*. Domus, no. 474, p. 52, June, 1969

Exhibitions

One-Man Shows	1961	Galerie Haro Lauhus, Cologne
	1962	Galerie J, Paris: Wall of oil drums set up in the rue Visconti
	1963	Galerie Schmela, Dusseldorf
	1963	Galleria Apollinaire, Milan
	1963	Galleria del Leone, Venice
	1963	Galleria la Salita, Rome
	1963	Galleria Apollinaire, Milan: Packed monument
	1964	Galerie Ad Libitum, Antwerp
	1964	Galleria G.E.Sperone, Turin
	1964	Galleria del Leone, Venice
	1964	Galerie Schmela, Dusseldorf
	1966	Stedelijk van Abbemuseum, Eindhoven
	1966	Leo Castelli Gallery, New York
	1966	Walker Art Centre, Minneapolis School of Arts, Minneapolis, Minnesota: 42 390 cubic feet package
	1967	Wide White Space Gallery, Antwerp
	1967	Galerie Der Spiegel, Cologne
	1968	John Gibson, Commissions Inc., New York
	1968	The Museum of Modern Art, New York
	1968	Institute of Contemporary Art, University of Pennsylvania, Philadelphia
	1968	Galleria del Leone, Venice
	1969	Lo Giudice Gallery, Chicago
	1969	Museum of Contemporary Art, Chicago
	1969	Wide White Space Gallery, Antwerp
Principal Group Shows	1960	Foundation Gulbenkian, Lisbon: Group K.W.Y., Société Nationale des Beaux Arts
	1960	Orsay-Ville: Proposition pour un jardin — Lieux poétiques
	1961	Galerie J, Paris: Nouvelles Aventures de l'Objet
	1961	Galerie Le Soleil dans la Tête, Paris: Group K.W.Y.
	1961	Cologne: Der Geist der Zeit

1962	Sidney Janis Gallery, New York: New Realists
1962	Galerie Creuze, Paris: Donner à voir, 2
1963	Neue Galerie im Künstlerhaus, Munich: Festival du Nouveau Réalisme
1963	Musée d'Art Moderne de la Ville de Paris: Salon Comparaisons
1963	St Peter's Abbey, Gand: Forum
1963	San Marino: IV Biennale
1963	Musée d'Art Moderne de la Ville de Paris: III Biennale des Jeunes
1964	Musée d'Art Moderne de la Ville de Paris: Salon Comparaisons
1964	Musée d'Art Moderne de la Ville de Paris: Salon de Mai
1964	Leo Castelli Gallery, New York: "4"
1964	Gemeente Museum, The Hague: Nieuwe Realisten
1964	Museum des 20.Jahrhunderts, Vienna: Pop etc.
1964	Akademie der Künste, Berlin: Neue Realisten
1965	Palais des Beaux Arts, Brussels: Pop Art, Nouveau Réalisme etc.
1966	Institute of Contemporary Art, University of Pennsylvania, Philadelphia: Aspect 1966
1966	Musée d'Art Moderne de la Ville de Paris: Salon de Mai
1966	Staatliche Kunsthalle Baden-Baden; Louisiana Museum, Copenhague; Valdagno: Premio Marzotto
1966	Goldovsky Gallery, New York: Sculpture 1966
1966	The Art Institute, Chicago: 68th American Exhibition
1966	Walker Art Centre, Minneapolis, Minnesota: Eight Sculptors: The Ambiguous Image
1966	American Federation of Arts, New York: Environments
1967	Stedelijk Museum, Amsterdam; Tate Gallery, London; Musée Galliera, Paris: Premio Marzotto
1967	Konsthall Lund, Sweden: Superlund
1967	Dwan Gallery, New York: Scale models and drawings
1967	R.Feigen Gallery, New York: Macrostructures
1967	Museum of Contemporary Crafts, New York: Monument and Tombstone
1967	Arts Council, Philadelphia, Pennsylvania: Museum of Merchandise

1967	Studiogalerie, Goethe University, Frankfort on Main
1967	Palazzo Grassi, Venice: Campo Vitale
1967	City Art Museum, St Louis, Missouri: 7 for 1967
1968	The Museum of Modern Art, New York; County Museum, Los Angeles; The Art Institute, Chicago: Dada, Surrealism and their Heritage
1968	Stedelijk van Abbemuseum, Eindhoven: Three Blind Mice
1968	A.M. Maeght Fondation, St Paul de Vence, France
1968	4. documenta, Kassel, Germany: 5600 cubic metres package
1968	Kunstverein, Cologne: Ars Multiplicata
1968	Festival of Two Worlds, Spoleto: Packed Tower and Packed Fountain
1968	Bern, Switzerland: Kunsthalle – packed
1968	Bratislava, Czechoslovakia: Danuvius 68
1968	Institut für moderne Kunst, Nuremberg: Von der Collage zur Assemblage
1968	Musée d'Art Moderne de la Ville de Paris: Salon de Mai
1968	Wallraf-Richartz-Museum, Cologne: W. Hahn Collection
1969	Mercer University, Macon, Georgia; Witte Memorial Museum, San Antonio, Texas: Inflated Image
1969	University of St Thomas, Houston, Texas: The Sky's the Limit
1969	Heidelberg: Intermedia '69
1969	John Gibson Commissions Inc., New York: Ecologic Art
1969	The Hayward Gallery, London: Pop Art reassessed

List of photographers